A1990s
CHILDHOOD

A **1990s**
CHILDHOOD

From Bum Bags to Tamagotchis

MICHAEL JOHNSON

The
History
Press

Front cover: School kids fashion shoot, August 1997, Sports Connection competition. (*Trinity Mirror*/Mirrorpix/Alamy Stock Photo)

First published 2018

The History Press
The Mill, Brimscombe Port
Stroud, Gloucestershire, GL5 2QG
www.thehistorypress.co.uk

© Michael Johnson, 2018

British Library Cataloguing in Publication Data.
A catalogue record for this book is available from the British Library.

ISBN 978 0 7509 8409 6

Typesetting and origination by The History Press
Printed and bound by CPI Group (UK) Ltd, Croydon, CR0 4YY

CONTENTS

Acknowledgements

With thanks to all those that have kindly supported me with feedback, memories and advice as well as enduring months of me waffling on about nineties trivia.

Thanks also to those who have contributed photography to this project through Wikimedia Commons including users: Brian Moody, Alan Light, The US National Archives, DeaPeaJay, Randop, Mgct1506, Zoyetu, JuneGloom07, Arnoldent, Michael Gorzka, Richard Goldschmidt, David Shankbone, Maxwell Hamilton, Bob McNeely and the US Air Force.

All other photos are from my own personal collection and were taken either by me, my dad David Johnson or my father-in-law Peter Julian. Thanks to my brother Martin Johnson for letting me share a photo of the two of us as children and also thanks to my wife Rachel Johnson and her sister-in-law Fiona Julian who have kindly given permission for me to use one of their old photos from before we met to illustrate nineties fashion.

Thanks also to the community of nostalgia fans at www.doyouremember.co.uk who helped with my research.

While every reasonable care has been taken to avoid any copyright infringements, should any valid issue arise then I will look to correct it in subsequent editions.

One

INTRODUCTION

We are the children of the nineties: a special collection of people who had the unique privilege and honour of being the final generation born in the last millennium. It's remarkable to think that we share the same century of birth as the very last of the Victorians, the same century that saw World Wars I and II take place, in which the aeroplane and the television were invented, and in which the majority of people either walked or rode horses instead of travelling by car. We are the last children to emerge from the twentieth century and we will be the last to remember what it was like growing up in the second millenium.

We will tell our children and our grandchildren of a time, long ago, when instead of sending messages to our friends on our smartphones, we would get on a bicycle, ride round to their house, knock on the door and ask if they could come out to play. We will share unbelievable tales of a time when we played with non-electronic toys and used our imaginations to conjure up stories and games to entertain ourselves. And our descendants will marvel at our descriptions of the good old days when children played in the streets until the light grew dim and it was time to come in for bathtime.

It seems somewhat fitting that, as the last generation of the twentieth century, we were also the last children to experience the relative purity and innocence of a traditional childhood untainted by smartphones, social media and cyber-bullying.

It's not that we were without technology in the nineties; on the contrary, we had just the right amount. We had computer games and electronic toys but they didn't dominate our lives. We were the masters of our Game Boys instead of the slaves of our smartphones and we were able to enjoy our technology free from the tyranny and pressure of the constant demands of social media.

Growing up in the nineties we experienced a quality of life undreamed of by our forefathers. We were healthier, lived

Tony Blair, the British Prime Minister between 1997 and 2007 and leader of the Labour Party between 1994 and 2007.

longer, had more disposable income and more recreation time than at any time before in human history. We had better cars, more TV channels, increasingly exotic holiday destinations and ate out more often.

The world entered a time of relative peace as we were finally free from the ever-present threat of global nuclear war following the collapse of the Soviet Union and the end of the Cold War; apartheid was successfully being dismantled in South Africa; the Oslo Accords negotiated a way for Israel and Palestine to coexist in peace; and the Good Friday Agreement brought a period of peace to the Troubles in Northern Ireland.

We were blissfully unaware of the impending threat of climate change and lived in the idyllic days of pre-9/11 and 7/7 security concerns. Even the most intimidating threat of the time, the Millennium Bug, failed to materialise.

The nineties were, without a doubt, the happiest ten years of our lives.

In 1990 the average house price in the UK was £59,587 rising to £74,638 by the end of the decade. The price of a loaf of bread was 50p and and a litre of petrol would set you back just 40p. Wages had increased significantly over the previous twenty years and workers aged 21 in 1995 earned 40 per cent more, after adjusting for inflation, by the age of 39 than those aged 21 in 1975 did up to the age of 39. Gross Domestic Product (GDP) per capita rose from around £14,000 in 1980 to over £18,000 by the beginning of the nineties and by the end of the decade had escalated to in excess of £22,000.

This relative increase in wealth resulted in a decline in overall poverty in the UK and a rise in consumer spending, which meant that we had more toys and gadgets than ever before and spent more money on our leisure and entertainment. For

some, shopping in itself became a source of entertainment, and with the wide availability of credit cards and in-store credit we began to hear the term 'shopaholic' being bandied around as people got themselves into serious trouble buying things they simply couldn't afford.

We didn't have streaming music or video yet so we bought our music from Our Price, the music shop, on CDs and cassette tapes; we rented VHS videos from the Blockbuster shop. Amazon didn't exist for most of the nineties so we bought our books from Borders or Waterstones and if we wanted toys, we'd go to one of the shiny new American Toys 'R' Us stores that had recently arrived in the UK.

Our parents named us with the most popular names at the time, which were Thomas, James, Jack, Daniel and Matthew for boys and Rebecca, Lauren, Jessica, Charlotte and Hannah for girls. The name James was so popular, in fact, that in one of my school classes four of the fifteen boys were called James, leading to numerous cases of mistaken identity and incorrectly assigned rebukes.

We played with Tamagotchis, Pokémon and Pogs, Furbies, Power Rangers and Teenage Mutant Ninja Turtles. We had Golden Grahams, Lucky Charms and Pop Tarts for breakfast, Nerds, Dweebs and Flumps between meals and had baked-bean pizzas, Turkey Twizzlers, McCain's Micro Chips and Frubes for dinner.

We belong to the demographic collective alternatively known as the Millennials or Generation Y, sandwiched between the earlier Generation X and the later Generation Z or Post-Millennials.

If you were to turn back the clock to 1990 and take a walk into town, you'd immediately notice a number of significant

differences compared to today. Driving past you on the roads would be an assortment of nineties cars, the most popular being the Ford Fiesta and the Ford Escort, followed by the Vauxhall Astra, Ford Mondeo, Rover 200, Vauxhall Cavalier, Vauxhall Corsa, VW Golf, Nissan Micra and Renault Clio. Of course, alongside all these 'new' cars there would still be plenty of older cars from the eighties and even seventies on the roads but it was easy to identify the nineties cars since they were generally a lot more curvy with smooth, computer-designed aerodynamic curves rather than the angular designs of the previous decade.

Everyone would be dressed differently too in the clothes of that awkward transitionary period between eighties and nineties fashions where the big hair and stonewash denim of the previous decade hadn't yet been fully eradicated and the cool, classic nineties styles like the Grunge look, tartan miniskirts and Rachel-from-*Friends* haircuts hadn't yet become popular.

The shops in the town would all be different and you would see long-forgotten gems like C&A, Dolcis, Morgan, Tammy Girl, Madhouse, the Sock Shop, the Sweater Shop, MK One, Past Times, Athena, Woolworths, Great Mills, Do It All and John Menzies.

There would be a noticeable absence of mobile phone shops, computer shops and drive-thru fast food restaurants, since they would all arrive later in the decade; coffee shops were few and far between, having not yet been popularised by American TV shows like *Friends* and *Frasier*. Amazingly, the first Starbucks didn't arrive in the UK until as late as 1998 when real coffee was still something of a rarity for the British. At this time, most people preferred to drink a hot beverage that really can't be called coffee: made with instant coffee granules like Nescafé

or Maxwell House, whitened with a spoonful of Coffee Mate powder instead of using milk or cream, and maybe a sachet of artificial sweetener or two in place of sugar. The resulting concoction neither looked nor tasted like real coffee but many people, to this day, prefer it to the potent brown liquid served at the new-fangled Starbucks chain.

Even the language was different in the nineties. If you told your friends that you were going to Google something they would have literally no idea what you were talking about, and if you asked them to DM or PM you they may have had some

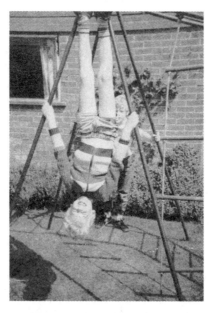

The author demonstrating what 'hanging around' meant to the children of the nineties.

real concerns about what you were suggesting. They would probably also spend hours trying to figure out what the various acronyms LOL, YOLO and ROFL meant and would likely assume that #hashtags were something that you either wore or ate.

You would also notice a lot more people smoking than today, since around one in three adults were smokers in 1990. Ten years later that figure would drop to one in four adults smoking and after another ten years it would reduce to just one in five. In fact, this was the last decade before smoking bans in public places came into effect so if you went into a restaurant or pub for lunch (with your parents, of course, because you were a kid), the air would often be so thick with second-hand smoke that you would passively smoke half a dozen cigarettes in the time it took to you to eat your ploughman's lunch.

Of course, the classic ploughman's lunch was still the main (and in some cases, only) food on offer in many pubs since this was a time when pubs were still pubs rather than the family restaurants with a bar attached that most pubs became after the smoking ban was introduced. If you wanted anything else to eat, your only choice might have been packets of peanuts, Mr Porky pork scratchings and those funny little scampi crisp things that would come in a green packet and hang on the wall behind the bar.

While it's true for many children that the nineties were the happiest time of our lives, it's important to remember that for others it was a decade of almost unimaginable suffering. The Gulf and Bosnian wars both took place in the early nineties and led to the deaths and serious injury of hundreds of thousands of people along with the destruction of countless homes and livelihoods; and the Rwandan genocide of 1994 resulted

in the mass murder of as many as a million people and the displacement of 2 million others.

In the UK things weren't perfect either, and around 1.8 million people faced the prospect of negative equity after house prices fell by over a quarter. The BSE or 'mad cow disease' epidemic also reached its peak in the mid-nineties, resulting in the slaughter of over 4 million cows and the consequential destruction of the livelihoods of many farmers.

On top of this, the nineties saw a marked increase in the use of heroin among the middle classes, and particularly those in the entertainment industry. The eighties had seen a growing awareness of the drug, and the risks of addiction and disease from needle use, and children's TV show *Grange Hill* famously featured a storyline which portrayed Zammo McGuire's drug addiction and launched the 'Just Say No!' campaign.

But by the nineties, the number of heroin users was still increasing and statistics for this period show that in 1993 there were an estimated 155 deaths in England and Wales from heroin and morphine use. By the mid-nineties the number of annual deaths had increased massively to around 400 and by the end of the decade that figure had doubled again, reflecting the severity of the problem.

While the nineties clearly had its fair share of troubles, for many of us growing up in the UK, the world seemed like a happy and safe place. We simply weren't aware of the troubles going on around the world or perhaps we didn't care. We had everything we could possibly want: toys and games, satellite TV and computer games, the latest Hollywood films and MTV. We even had our very own European Disney theme park that had just opened a short distance away in Paris, and a train that would take us there in a brand new tunnel under the English Channel.

We were inundated with new music in the nineties and saw the rise of Britpop and Madchester, Grunge and Rave and Techno and Girl Power. We listened to music on our new CD Walkman and Minidisc players and by the end of the decade replaced these with the even newer MP3 players.

Our favourite songs of the decade according to the number of sales were 'Candle in the Wind' (1997) by Elton John, which was a tribute to the late Princess Diana, 'Unchained Melody' (1995) the Robson and Jerome version that had first been sung on the TV show *Solider Soldier* and 'Love Is All Around' (1994) by Wet Wet Wet, whose success can be attributed to its use as the soundtrack to the film *Four Weddings and a Funeral*.

At first glance it would seem that our taste in music in the nineties was somewhat soppy and sentimental but the next best-selling song of the nineties, 'Barbie Girl' (1997) by Aqua, shows that we were actually all just a little bit 'Insane in the Brain', to quote nineties hip-hoppers Cypress Hill. This is further evidenced by the fact that the British public bought over a million copies of 'Teletubbies Say "Eh-Oh!"' in 1997 and gave Mr Blobby the number one spot in the charts for Christmas 1993 with his imaginatively titled song 'Mr Blobby'.

We also saw the arrival of fantastic new TV shows, many of which were targeted directly at us kids like *Live and Kicking* with Zoë Ball and Jamie Theakston, and *SM:tv Live* with Ant and Dec and Cat Deeley, with memorable features like 'Wonky Donkey' and 'Challenge Ant'.

There were fantastic new comedies including *The Fast Show*, *Father Ted* and *One Foot in the Grave*, brand new American dramas like *Baywatch*, *The X-Files* and *Beverley Hills 90210* and we also enjoyed the latest family entertainment with *Noel's House Party*, *Gladiators* and *Stars in Their Eyes*.

The nineties also brought us some of the greatest films ever made and, with the phenomenal advances in technology and computerised special effects that were taking place at the time, we saw the film industry go through a transformation as significant as the revolution when cinema transitioned from silent movies to 'talkies' or from black and white to colour.

We were the first generation to witness the ultra-realistic resurrection of the dinosaurs in *Jurassic Park* (1993) and watch a convincing worldwide alien invasion in *Independence Day* (1996). We saw mind-bending special effects in *Terminator 2* (1991) and *The Matrix* (1999), and witnessed the introduction of a whole new genre of film with the first feature-length computer-animated movies like *Toy Story* (1995), *Antz* (1998) and *A Bug's Life* (1998).

We enjoyed new comedies like *Home Alone* (1990), *Groundhog Day* (1993) and *Clueless* (1995), were treated to

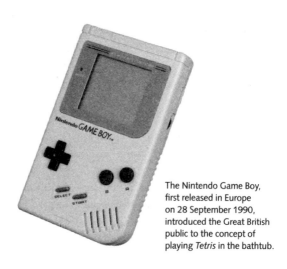

The Nintendo Game Boy, first released in Europe on 28 September 1990, introduced the Great British public to the concept of playing *Tetris* in the bathtub.

three new James Bond films with Pierce Brosnan playing the titular character, and saw the release of critically acclaimed cinematic masterpieces like *Thelma and Louise* (1991), *Forrest Gump* (1994), *Schindler's List* (1993) and of course, the most high-brow of them all, *Ace Ventura: Pet Detective* (1994).

Advances in computer technology meant that we now saw the arrival of super-advanced games consoles like the PlayStation and hand-held games machines like the Game Boy. Home computers moved on from the previous generation of Commodore 64s and ZX Spectrums and now we had new, super-powerful gaming computers like the Commodore Amiga 500 and the Atari ST. By the end of the decade we also witnessed the birth of the first iMac computers with built-in modems allowing us to access the exciting new world of the World Wide Web.

The arrival of the Web in the nineties was as significant an innovation as the invention of the internal combustion engine, the television or even the wheel, although few people realised it at the time. We unwittingly witnessed the birth of a new technology that was going to revolutionise business, politics, entertainment and virtually every other area of our lives in the near future, and yet we had no idea that the nineties would be the last decade in which we would actually need to look things up in books, send written letters to people or talk to our friends in person if we wanted to find out what they had for breakfast.

The nineties was also a time of political interest, beginning with Margaret Thatcher, our Prime Minister at the beginning of the decade, being ousted by her own party and replaced with John Major in 1990. In 1997 we then saw the switch from a Conservative government that had been in place

since 1979 to a Labour government with Tony Blair as Prime Minister. In the USA the decade began with George Bush Senior as President, followed in 1993 by President Bill Clinton, the man who would famously lie to the world's press about his extra-marital relationship with White House intern Monica Lewinsky, ultimately leading to his impeachment on charges of perjury and obstruction of justice.

The politics of Europe also changed significantly after the signing of the Maastricht Treaty in 1992 paved the way for the establishment of the 'Three Pillars' structure of the European Union and the introduction of the single European currency, the euro, which was first used in 1999. Elsewhere in Europe the demise of the Soviet Union had brought about the breakup of Yugoslavia and the reunification of East and West Germany after forty-five years of separation along the Berlin Wall.

At the very beginning of the decade, we still shared the planet with a number of great people who were shortly to leave us, such as Princess Diana (1 July 1961–31 August 1997), Mother Theresa (26 August 1910–5 September 1997), Freddie Mercury (5 September 1946–24 November 1991), Gene Kelly (23 August 1912–2 February 1996), Ginger Rogers (16 July 1911–25 April 1995), Jimmy Stewart (20 May 1908–2 July 1997), Marlene Dietrich (27 December 1901–6 May 1992), Greta Garbo (18 September 1905–15 April 1990), Audrey Hepburn (4 May 1929–20 January 1993), George Burns (20 January 1896–9 March 1996), Frank Sinatra (12 December 1915–14 May 1998), Burt Lancaster (2 November 1913–20 October 1994), John Candy (31 October 1950–4 March 1994) and Benny Hill (21 January 1924–20 April 1992).

And at the same time, the world was bracing itself for the arrival of the next generation of celebrity including the likes

of Justin Bieber (born 1 March 1994), Harry Styles (born 1 February 1994) and Miley Cyrus (born 23 November 1992).

The nineties was a period of unparalleled peace and prosperity in the history of the western world. A time of health, wealth and technological progress. Our lives had never been so easy, so carefree or so enjoyable.

We had reached the pinnacle of human achievement in the twentieth century and hadn't yet faced the threats of the twenty-first. We were privileged, we were spoiled and we were the children of the nineties.

Two

FASHION

1 January 1990: as the first dawn of the new decade lazily stretches its orange fingers across the skies of London, a blanket of silence lies over the city that, a few hours before, was the site of wild and exuberant New Year's celebrations. As the revellers now lie dreaming of all the new decade will bring, the silence is broken only by the faint clatter of an empty can of Hofmeister rolling into the gutter.

As the sun rises through the early mist, the nation begins to awake. As bleary eyes are rubbed clear, many head to the windows to get their first glimpse of the bright new decade – the nineties.

The eighties are over at last. This thought brings a thrill of excitement to each person. No longer do people have to wear ridiculous-looking neon-coloured leg warmers and mullet haircuts. Gone are the espadrilles and shoulder pads, the ra-ra skirts and the white stilettos. Never more will people wear head-to-toe denim or suit jackets with the sleeves rolled up.

Smoke begins to rise in the gardens of suburban homes across the country as a funeral pyre of eighties clothes are ceremonially burned to ashes, liberating the wardrobes

of the masses. Lines of excited people form outside the doors of Tammy Girl, Dolcis and C&A waiting with eager anticipation for the fanfare that will herald the arrival of nineties fashion ...

In reality the transition between eighties and nineties fashion was a far more gradual affair and at the beginning of the new decade the clothes that people were wearing were pretty much the same as the clothes they were wearing at the end of the last. Men with mullet haircuts were still commonplace and shoulder pads and big hair for women was still *de rigueur*, but gradually, little by little, eighties fashion receded and gave way to tantalising glimpses of what was to come.

When it comes to the fashion of the nineties, there's a feeling that it is less well-defined perhaps than the fashions of other decades. The sixties, with their miniskirts, bright colours and black and white patterns, are easily recognised, as are the seventies with flares, platform boots and lots of glitter and satin. The eighties, with their shoulder pads, big hair and leg warmers, are equally easy to identify, but if you were invited to attend a nineties-themed party, would you know what to wear?

With the influence of cinema, television and music on fashion and culture exponentially increasing with each passing decade, we reached a point in the nineties where we were saturated with imagery and messages telling us how to dress, talk and behave. With hundreds of TV and radio stations now available to most people, each interest group had its own set of influencers, resulting in dozens of different fashion niches, each tailored to the lifestyle of a particular demographic.

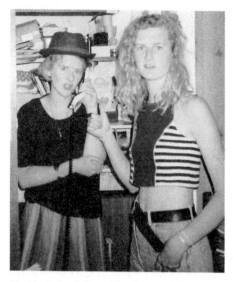

My sister-in-law (left) modelling her own distinct take on nineties fashion, and my future wife (right) sporting more traditional nineties 'mum jeans' and a crop top.

Rather than seeing the mass appeal fashion trends of former years, like the original miniskirt craze, we now saw micro-fashion trends that targeted a small but dedicated group of followers whose interests and lifestyle could be quite accurately identified simply by the clothes they wore.

This phenomenon can perhaps be best seen in the slew of adolescent-themed TV shows and movies emanating from America in the nineties in which high-school pupils belonged to cliquey groups such as skater boys, stoners, the heavy metal crowd, valley girls and spoiled rich kids, jocks, preppies, hip-hop kids, Grunge fans, goths and of course nerds. Each little group

had its own defining fashion characteristics: the skater boys wore baggy trousers and trainers and back-to-front baseball caps; valley girls and rich kids wore stylish, expensive clothes with prominent designer labels; jocks wore varsity jackets; the goths dressed all in black and wore heavy eye make-up with powder-white faces and piercings; and the nerds who, in their attempt to reject fashion trends entirely, somehow created one of the strongest trends of all, wore the heavy-rimmed spectacles, cardigans, bow ties, clashing patterns etc. that became an inspiration for the millennial Hipster movement.

It also seems that we made a conscious and deliberate effort to move away from some of the more extreme and glamorous fashions of the previous decades and adopt a more minimalist and sophisticated approach to our clothing. We were now far more interested in brands and labels and were introduced to the concept of 'supermodels' who showed us that there was more to fashion than just competing with each other for who had the biggest hair and shoulder pads.

In fact we moved so far away from the glamour of the eighties that we nearly went off the other end of the scale with the Grunge movement which eschewed the widely accepted belief that fashion was about making you look good. What started as an anti-fashion statement worn by rock musicians in Seattle became a widespread fashion trend popularised largely by the band Nirvana and, in particular, the iconic lead singer Kurt Cobain. Grunge clothing for men usually comprised an assortment of baggy and ill-fitting clothes purchased from charity shops, paired with ripped jeans, black military-style boots and often an unbuttoned flannel shirt over the top for good measure. The less flattering the look, the better! Of course it was no good having a snazzy haircut with a Grunge outfit, so

the general idea was to let your hair grow to an awkwardly shaggy length and rarely brush it, resulting in that been-up-all-night-playing-rock-music-on-my-guitar look. This was the perfect fashion trend for many men whose naturally dishevelled appearance was less about fashion-consciousness than it was their innate inability to dress well.

Women, on the other hand, generally took more effort perfecting their anti-fashion statement, carefully planning the exact location for each of the rips in their low-rise jeans and spending an extraordinary amount of time fixing up their hair to look as though it hadn't been fixed up at all. Kurt Cobain's wife, Courtney Love, proved to be a key inspiration for female Grunge fashion and is credited with debuting the 'Kinderwhore' style which usually comprised some form of ripped baby-doll or slip dress, knee-high socks, hair that looked like you had been sleeping rough and heavy make-up with a particular emphasis on black eyeliner. The overall impression was of somebody who lived on the streets and had been attacked on the way to wherever they were going. The central concept of Grunge fashion was generally to look *Elegantly Wasted*, to use the name of a 1997 INXS album. Kurt and Courtney pulled this off to perfection.

The relationship between music and fashion had grown much closer during the previous decade with the advent of MTV, which provided non-stop music videos and introduced us to an onslaught of new fashion trends, largely from the UK and USA.

Pop princesses Britney Spears, Christina Aguilera and Jessica Simpson frequently modelled super-low-rise jeans paired with either boob tubes or crop tops that exposed a sizeable portion of midriff. In particular, Britney and Christina seemed to be

engaged in an unofficial competition to see who could expose the most of their abdomen with both popsters ultimately reaching the limits in terms of taste and decency.

Another fan of the crop top and low-risers was Gwen Stefani from the band No Doubt who also became famous for her use of Hindu-style bindis on her forehead as a fashion accessory, along with other facial jewellery. If she wasn't wearing low-rise trousers, though, she would sometimes wear a sari wrap as a skirt, presumably in an attempt to co-ordinate culturally with her headwear.

The boy bands of the era set the trend for the boys and the men with Take That, NSYNC, The Backstreet Boys, Boyz II Men and Westlife all contributing in different ways. One of the common themes among the bands was dressing all in white, from head to toe. This may have looked good in a music video, but in reality, anyone dressed all in white in public was usually mistaken for either (a) a sailor, (b) a nurse, (c) the milkman or (d) an angel.

Looking at photos of these bands in the nineties, there's another common theme of male toplessness. Prior to this decade, toplessness was really rather rare in the music world but now every boy band, at some point or other, ripped off their tops and exposed their rippling six-pack stomachs and perky pecs to their adoring fans (mostly teenage girls, for obvious reasons). Even if they kept their tops on, they would make sure their shirt was at least unbuttoned most of the way or that they were wearing something revealing to show off their toned physical perfection.

Several of the boy bands also took to wearing dungarees and – I'm not sure who agreed on this – it seemed to be unanimously decided that it would only be cool to wear dungarees

if you let one of the straps hang down, or both straps with the top down if you were Marky Mark and had the body of a Greek god.

Despite there having been plenty of all-female pop groups in previous decades, the marketing concept of a girl band didn't really exist until the nineties and was a direct response to the overwhelming number of boy bands littering the charts. It is generally agreed that the first of the true girl bands were the Spice Girls, who burst on to the scene in 1994 with more energy than a six-pack of Red Bull and a packet of Pro Plus (both of which had just recently been invented).

Jane Leeves (Daphne in *Frasier*) outside the 1995 Emmy Awards ceremony wearing a very nineties combination of a slip dress and Rachel-from-*Friends* hairstyle.

The Spice Girls' flamboyant fashion was a 'Sporty Spice' high kick in the face for the great British public, who really didn't know what to make of 'girl power' at first. The personalities of each of the girls was reflected in their outfits, with 'Sporty Spice' dressing in a variety of brightly coloured and quite masculine athletics clothing. 'Baby Spice' dressed like a little girl in slip dresses with her hair up in bunches, while 'Posh Spice' brought a touch of elegance to the proceedings usually wearing some kind of classy cocktail dress. 'Scary Spice' showed her wild side by wearing a lot of animal print and then, of course, there was 'Ginger Spice', whose Union Jack dress has been widely acknowledged as one of the most iconic dresses of the last century. I use the term 'dress' rather loosely since it has always been my belief that a dress is supposed to provide some cover to the bottom half of the wearer and this garment certainly did not conform to that convention.

While the Spice Girls undoubtedly led the pack of girl bands who influenced the fashion trends of the nineties, mention must also be given to All Saints, TLC, Destiny's Child and En Vogue, who all, in their own ways, contributed to the style of the time. Girl bands who had less influence over the clothing of the British public were Atomic Kitten, Cleopatra (Comin' Atcha!) and B★Witched, whose wardrobes seemed to consist of nothing but denim.

Some of the fashion attempts seen in music videos at the time never really caught on, thankfully, such as Scary Spice's leopard-print jumpsuit or Michael Jackson's bizarre white sock/black loafer/half-mast trouser combo. Neither was Keith Flint's Firestarter (twisted Firestarter) image particularly popular, especially among the elderly and those of a nervous disposition. And then, of course, you had that perky and

peculiar pixie of pop, Björk, whose unique and extreme fashion sense defied both description and imitation.

Equally inimitable was Madonna, whose uninhibited fashion sense was rarely suitable for public display although her outfits often inspired shifts in the lofty world of catwalk fashion. Eventually these changes would ripple down to the masses in the form of a much more subtle and palatable garment though still retaining the essence of the original. Madonna had already forced major changes in the fashion world back in the eighties with her shocking costumes that redefined underwear as outerwear and this trend continued into the nineties when, in 1990, on her *Blonde Ambition* tour, she wore a pink corset with the now iconic cone bra that was permanently in danger of having someone's eye out.

The costume had been designed by famous French fashionista Jean-Paul Gaultier, who frequently collaborated with Madonna and was inspired by the bullet-bras of the 1950s. While the general public didn't all rush out to buy cone-shaped bras, Madonna's made such a strong impact that it is still inspiring celebrities, trendsetters and the fashion world today. Variations of this bra have been worn in music videos by Lady Gaga, Katy Perry and Kylie Minogue among others. Apparently the original conical bra/corset from Madonna's tour was sold at auction in 2012 for the princely sum of £42,000.

A quite different musical influence of the era was the 'Madchester' scene, which was characterised by bands such as the Charlatans, the Stone Roses, the Inspiral Carpets, and Happy Mondays. This Manchester-based musical happening led to the so-called 'Baggy' fashion whose unimaginative name accurately described the trend of wearing baggy and sometimes flared jeans usually paired with a tie-dye T-shirt and

fisherman's hat. This look was especially versatile since it enabled the wearer to blend in with the indie-rock followers in Manchester, but also appear equally appropriately dressed at an all-night rave or at a retro festival full of hippies.

Towards the end of the 'Madchester' scene, we saw the emergence of the 'Britpop' scene of which the undisputed kings were either Oasis or Blur, depending on which side of the battle line you were on. The rapidly increasing popularity of both these bands, fuelled by their intense rivalry as much as their groundbreaking music, led to many people declaring their loyalty to one or other of the bands and sporting suitable clothing that would reflect their preference. If you were an Oasis fan, chances are you would be seen wearing some form of hooded parka jacket, perhaps a pair of Lennon-esque round sunglasses, a collarless shirt and a haircut that matched the messy mops of either of the two Gallagher brothers. If, on the other hand, you were a Blur fan (and of course you had to be one *or* the other), then you may have opted to wear a tracksuit top over a polo shirt with jeans and a pair of Adidas trainers topped off by an imitation of Damon Albarn's signature haircut. The best way I can describe this, for those who do not remember, is that it was like the male equivalent of a pixie cut. Short and feathered, and worn in a way that looked meticulously scruffy. Every individual hair was just the right amount of out-of-place.

Fortunately, the mullet haircut of the eighties had become virtually extinct by the nineties (except in Germany where it will always be fashionable) but it was replaced by another follicular abomination: the 'curtains' haircut, which was essentially a centre-parting in medium-length hair. Everyone from David Beckham and Peter Andre to Johnny Depp and Leonardo

DiCaprio was seen sporting a pair of curtains on their head at some point. I too grew my hair into curtains, as did my brother and most of my friends. Looking back at photos of curtains haircuts now makes me cringe and shudder, but at the time it was probably the coolest haircut a boy or a man could have. Possibly the most perfect example of curtains at the time was sported by teen heart-throb Adam Rickitt who played Nick Tilsley in *Coronation Street* (we called it by its full name in those days – none of this *Corrie* business back then) whose golden locks fell into a perfect parabola/gothic arch.

For women, the defining haircut of the decade was, without a doubt, the Rachel-from-*Friends* haircut which first appeared on the scene in the mid-nineties. To start with, women would take a picture of Jennifer Aniston along to the hair salon and ask for the same haircut, but within a few short months there was no need to take the photo any more, you just needed to ask for 'the Rachel' and the stylist would nod knowingly and begin their twentieth Rachel haircut that day. By some accounts, at the height of its popularity if you went in and asked for something other than a Rachel haircut it didn't make much difference, you still came out with a Rachel haircut.

The style was essentially a kind of messy bouffant bob which framed the face rather nicely but, as the seasons of *Friends* progressed, the hairstyle evolved and became longer and less bobby. Of course, the Rachel haircut looked great on Jennifer Aniston, but many women were severely disappointed when they discovered that the style didn't look so great on them for some reason. In fact, it took a while but many women came to realise that it wasn't so much Jennifer Aniston's hairstyle that looked great, it was more that Jennifer Aniston herself looked

great and pretty much any hairstyle she chose would have looked good on her.

And it wasn't just her hair that looked good. Jennifer Aniston's character Rachel Green, in the hugely popular sitcom *Friends*, had become a fully fledged fashion icon and had as much of an influence on women's wardrobes as she had on their hairstyles. Since her character was a fashion-obsessed New Yorker who actually worked in the fashion industry, it gave her plenty of opportunity to wear hundreds of eye-catching outfits throughout the show's ten seasons. One of the more memorable outfits included a combination of a tartan miniskirt, white below-the-knee socks and a crop sweater, while another was a charcoal miniskirt with knee-high boots and a layered top. Yet another comprised a black miniskirt with black boots and a black tank top with a white tee underneath. You may be spotting a theme here ...

While Mary Quant pioneered the miniskirt back in the 1960s, they had fallen out of fashion during the seventies and eighties but by the nineties they were making a comeback thanks, in part, to Jennifer Aniston and also Alicia Silverstone who flaunted a series of bold miniskirts in the 1995 movie *Clueless*. Silverstone's character, Cher, was a Beverley Hills 'valley girl' with a rich daddy and a penchant for shopping. Most of the outfits she wore in the film included a miniskirt, often paired with a matching jacket and a pair of long socks. Her famous bright yellow tartan miniskirt and jacket ensemble is one of the most iconic outfits of the decade and is consequently a popular choice for nineties fancy-dress party costumes today.

Cher's dress style echoed that of air-headed Hilary Banks from *The Fresh Prince of Bel Air* who was also a spoiled rich

girl living with her daddy in a mansion in LA. From the first episode of the comedy in 1990, we were treated to a variety of wild and expensive costumes each week from snobbish Hilary whose sole ambition in life was to shop for expensive designer clothes and find a husband who would pay the credit card bill. Hilary's self-centred, shallow personality contributed to her failure to hold down relationships with men but, in her mind, the problem was that men were intimated by her beauty, leading to her famous line, 'I'm a beautiful woman trapped in an even more beautiful woman's body!'

All of Hilary's clothes were costly designer numbers that most people would never have the wealth to imitate, which is probably just as well since some of her outfits were truly horrendous. One of her more memorable fashion *faux pas* was a jacket with broad vertical stripes in cyan, magenta, yellow and black, taking inspiration from the colours of the CMYK four-colour print process.

The Fresh Prince of Bel Air also influenced us through the eclectic wardrobe of Will Smith, whose extrovert personality was often expressed in his bold fashion choices: bright colours, clashing patterns, a baseball cap worn sideways and a flat-top haircut.

Will's vivacious style was contrasted with nerdy cousin Carlton's preppy, country-club look that usually involved sharply creased trousers, a classic button-down shirt and a pastel-coloured sweater draped over the shoulders as an accent. While Will, Carlton, Hilary and even Aunt Vivian may have inspired some imitators, it is highly doubtful whether anyone was ever inspired by Uncle Phil's sleeveless cardigans.

The new wave of entertainment from America undoubtedly had a stronger influence on UK fashion than most of

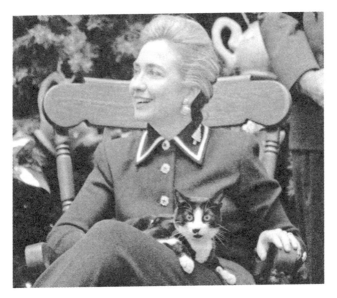

First Lady of the USA Hillary Clinton with Socks the cat in 1995 looking distinctly like a James Bond 'baddie' in one of her many, many trouser suits.

our own home-grown TV shows and movies, which is hardly surprising when you consider that, at the same time *The Fresh Prince of Bel Air* was colourfully inspiring the clothing of the younger generations, one of the most popular comedies in England was *Last of the Summer Wine*. The cloth cap and tweed jacket ensemble of Cleggy, or Norah Batty's curlers and tabard look, really never stood a chance against the Hollywood glamour, although it is a personal theory of mine that Compo was the original inspiration for the Grunge movement and that Kurt Cobain was actually a secret fan of Roy Clarke comedies.

TV shows like *Beverley Hills 90210* demonstrated a more sophisticated and grown-up look, with the characters dressing in smart designer clothing and sporting slick haircuts. Their fashion sense was impeccable, except for their apparent preoccupation with what we now call 'mum jeans', the pale, high-waisted, straight-cut and ill-fitting jeans that make even the most curvaceous person look shapeless.

The kids of *Saved by the Bell* each had their own unique style, too, with Zack modelling some truly hideous, brightly coloured and boldly patterned knitted sweaters and his girl-friend Kelly wearing outfits that were way too revealing and risqué for the supposed age of her character. And then, of course, there was Screech, that oddball character for whom a Hawaiian shirt was a boring understatement. His bizarre sense of style incorporated some of the most outrageous shirts ever seen on television paired with half-mast trousers held up by suspenders. Not a good look, even by nineties standards.

Another US sitcom of this era, *Blossom*, birthed a new and unlikely fashion icon in the shape of actress Mayim Bialik who is arguably more famous for playing Sheldon Cooper's severely fashion-impaired girlfriend, Amy Farrah Fowler, in *The Big Bang Theory*. Back in the nineties, however, Bialik played the character of Blossom in the eponymously titled show and became something of a trend-setter after introducing us to her big floppy hat with a flower on it that became her trademark.

The floppy hat was already emerging as a potential new style in the late eighties but it was Blossom, in 1990, who really popularised it. In fact the floppy hat of Blossom is such a an iconic item of clothing that it joins Madonna's pointy bra, Geri Halliwell's Union Jack dress and the Rachel haircut in my imaginary nineties fashion Hall of Fame.

An early adopter of the floppy hat movement was Sarah Jessica Parker, who was seen, on one occasion in the late eighties, wearing a large black floppy hat with a big white flower along with a pair of stripy blue and white dungarees and a white jacket. At this point, however, Parker was little known and her fashion influence was very limited since her big break in TV was not to come until the end of the decade when she landed the starring role of Carrie Bradshaw in *Sex and the City*.

This brave new romantic comedy series followed the lives of four New Yorker women, Carrie Bradshaw, Samantha Jones, Charlotte York and Miranda Hobbes, and pushed the boundaries of modern femininity and female sexuality while also inspiring women around the world with the expensive and chic outfits that the characters wore.

One of the most famous outfits from any of the ninety-four episodes is actually the very first of Carrie Bradshaw's: a white tutu skirt and sleeveless powder-pink top. Patricia Field, *Sex and the City*'s internationally renowned costume designer, revealed that she actually found the tutu skirt in a show-room bin and it cost just $5 – quite a contrast to the Vivienne Westwood wedding dress that Carrie later wore in another episode which cost around £13,000.

While the fashions of *Sex and the City* were appealing, they were hardly imitable since most of Carrie's costumes cost thousands of dollars each. A more affordable option for women who wanted to look smart and self-confident in the city was to wear trouser suits, which became surprisingly popular in the nineties, despite their generally unflattering appearance.

Agent Dana Scully in the newly released *The X-Files* US TV drama always wore trouser suits, which reinforced her character's tough, no-nonsense image but did nothing to enhance

her figure. First Lady of the USA at the time, Hillary Clinton, was also a big fan of the trouser suit and was rarely seen wearing anything else. She literally had trouser suits in every colour of the rainbow but, unlike former First Ladies Jackie-O and Nancy Reagan, Hillary Clinton never really made much of an impact on the fashion world.

The one person who rocked the trouser-suit look and also inspired the fashion of the masses was Princess Diana. Her impeccable dress sense matched with her good looks and high-profile media coverage meant that she did more to inspire British fashion in the nineties than perhaps any other individual of the time. Not only did she look good in a trouser suit, Princess Di looked good in pretty much anything she wore which, at times, was as simple as a pair of blue jeans and a plain white shirt – a look that could easily be copied, even on a limited budget.

Trickier to copy for most people, however, were the exquisite gowns, designer dresses and eye-wateringly expensive jewellery. In this regard, Diana's fashion was aspirational more than achievable but that didn't stop some people trying to imitate her looks through the limited offerings of C&A and British Home Stores.

At the same time that Princess Diana was on the cover of virtually every fashion magazine, a new and disturbing fashion trend was emerging within the adverts of those very same magazines. The anti-fashion sentiment of Grunge had been joined by the anti-beauty cynicism of Heroin-Chic which made its first appearance in the early nineties, seemingly in response to the advent of supermodel culture. As Claudia Schiffer, Cindy Crawford, Naomi Campbell, Linda Evangelista and Christy Turlington elevated the standard for female beauty

to ever more unattainable levels, Calvin Klein was busily producing photo shoots with waifish, pale-skinned models like Kate Moss, with dark circles under their eyes giving the impression of drug addiction.

It was hard to imagine that such a disturbing and depressing image could appeal to anyone, but the truth is that it tapped into a desire for rebellion against fashion and physical perfection among some people and gave strength to the feminist movement with the argument that women should not just be seen as objects of beauty.

Developing the idea of gender equality a step further, Calvin Klein embraced and promoted the concept of androgyny, with black and white advertising campaigns featuring groups of models whose clothing did not define or conform to their gender identity. In fact, in nearly all the adverts, the models were shown wearing nothing more than plain black underwear or a pair of jeans and white T-shirt, deliberately removing any clues relating to their gender or sexuality. The accompanying CK One perfume was a fresh unisex fragrance targeted equally at both men and women.

This campaign came at a time when the boundaries of gender and sexuality were becoming increasingly blurred and, in particular, the traditional idea of masculinity was being rewritten, leading to the adoption, in 1994, of the word 'metrosexual', which describes a heterosexual man who is in touch with his feminine side and has a strong interest in grooming and fashion.

Sexuality for women was given a boost that same year with the introduction of an uplifting (excuse the pun) new fashion phenomenon: the Wonderbra. Described as either empowering or degrading for women, depending on the perspective

of the commentator, the Wonderbra became an overnight sensation with millions of women rushing out to buy the push-up bra that promised to give them the perfect cleavage.

The advertising campaign for the Wonderbra became notorious after billboards, showing Czech-born model Eva Herzigova in just her Wonderbra and knickers, next to the slogan 'Hello Boys!', reportedly led to numerous car accidents caused by distracted drivers.

Thanks, in part, to this dubious achievement, the poster was voted in at number ten in a 'Poster of the Century' contest. Like that's even a thing.

Fashion has always been a reflection of the culture of the times, an indicator of social progress and a way for people to express their unique personalities, and in this regard, the nineties are no different to any other decade. The distinguishing characteristic of nineties fashion, though, that sets it apart from everything that came before, is its sheer diversity and eclecticism.

From Grunge to Glamour, baggy jeans to mum jeans, miniskirts to dungarees – never before was there a decade that offered so much inspiration and so many choices to a generation that had so much disposable income to spend on clothing.

While the trend for diversity has increased in each subsequent decade, the nineties was a milestone in fashion history, marking the beginning of a new era of personal fashion.

Three

MUSIC

In the same way that a familiar smell can transport you to a distant memory in an instant, music has the power to take you on a journey to the exact time and place that you first heard a song and simultaneously reignite the emotions you felt at the time.

For those of us who grew up in the nineties, the pop music of the decade provides us with a common soundtrack to our childhoods, one that we can revisit at any time through a pair of headphones. By listening to the songs of our youth we relive the memories of our formative years and remember the people, places and events that helped shape us into who we are today. Every person has a different memory to accompany each song – one will remember the good times it represents while another will recall the heartbreak they felt – but we, the children of the nineties, are united by this diverse and emotive decade of music that we share.

We are the Nirvana generation, the children of Britpop music and Madchester. We are the ones who know all the words to 'Common People' by Pulp and know all the moves to the Macarena.

We are the people who witnessed Bryan Adams spend sixteen weeks at number one in the UK charts with '(Everything I Do) I Do It for You' and we are the ones who saw the Spice Girls spice up our lives and tell us they 'really, really, really want to zigazig-ah'.

Together we stand, shoulder to shoulder with our fellow Generation Y comrades as the Outhere Brothers call, 'Boom, Boom, Boom! Let me hear you say wayo ...' and in response we shout as one voice, 'WAYO!'

The nineties represents arguably the most diverse decade in musical history up to that point, largely as the result of an exponential growth in personal media consumption beginning a few years earlier. At the beginning of the decade, most of us were still recording music from the radio on to mix tapes and playing them on a Walkman portable music player. Our main source of new music was Radio 1 and *Top of the Pops*, and if we wanted to buy music we had to go to record shops like Our Price where CDs were now replacing vinyl and cassette tapes.

MTV Europe had launched in the UK just a few years earlier in 1987 but relatively few people had access to satellite or cable television with many homes in the UK, mine included, having just four television channels to choose from and radio choices limited to BBC Radio and a handful of local stations.

But by the end of the decade, we had taken a quantum leap forward in music technology and distribution, and we were now downloading music directly from the Internet on to MP3 players and had access to hundreds of television channels and

virtually unlimited radio stations catering to every genre and taste in music.

During this process of musical emancipation, we saw the divergence of popular music into an increasing number of sub-genres representing the interests and influences of an eclectic audience hungry for more and more new music.

Traditional pop music continued to be highly successful and popular, but we now saw house and techno music rise in prominence along with other electronic music such as trance, rave, drum and bass, garage and jungle. An increased European influence brought us Eurodance and Europop music and the hip-hop music scene evolved and blended with soul, funk and jazz music to produce hip-hop soul, new jack swing and g-funk, among other things.

Rock music saw the arrival of Grunge, Britpop and Madchester, along with a popular alt-rock and indie scene and bands like Rage against the Machine and the Red Hot Chili Peppers blended funk, hip-hop and rock into new styles like funk-metal.

Despite the enormous variety of musical styles now available, the pop, pop-rock and dance genres still remained dominant and musical giants such as Michael Jackson and Madonna were in no way diminished. In 1991 Michael Jackson released his *Dangerous* album which sold around 35 million copies, following up with *HIStory* which sold a further 20 million copies. He also had number one hits in the UK with 'Black or White', 'You Are Not Alone', 'Earth Song' and 'Blood on the Dance Floor'.

Cementing her seamless transition from eighties to nineties pop music was Madonna, with her single 'Vogue', which

Flat Eric, the head-bopping puppet from the Levi's Sta-Prest advert.

was actually released in late 1989 but didn't reach number one in the UK charts until early 1990. Shortly after that, in 1992, Madonna released her highly controversial album *Erotica* along with the accompanying not-for-your-mum's-coffee-table book simply entitled *Sex*. At the end of the decade, Madonna was still going strong and released her album *Ray of Light* which sold over 16 million copies and she also had a number one hit with 'Frozen'.

Alongside the established names in the pop music industry, we were introduced to a wealth of new talent including former actresses Britney Spears, Christina Aguilera and Jennifer Lopez.

Britney caused a stir as she arrived towards the end of the decade dressed as a schoolgirl in the now iconic music video for '... Baby One More Time' set in an American high school. Doe-eyed Britney shimmied her way down the school corridors in knee-high socks, miniskirt, knotted school blouse and pig-tails with a generous helping of Lolita-esque pouting and provocation.

Sometime rival and former acting colleague Christina Aguilera appeared around the same time with her debut single 'Genie in a Bottle', which reached number one in the UK charts in October 1999 and treated us to a music video of the aforementioned diva writhing around in some sand dunes and sporting a pair of what looked like orange convict trousers.

Meanwhile, Jennifer Lopez, as she was known back then, (not J.Lo or Jenny from the Block or whatever she's known as these days), arrived earlier in the decade as a backing dancer for boy band New Kids on the Block, who incidentally had the very first UK number one of the nineties with 'Hangin' Tough'. After a brief stint as a backing dancer for Janet Jackson, she worked through successive acting roles, making a name for herself in Hollywood and eventually appearing in such legendarily bad movies as *Anaconda* (1997) and the CGI kids' film *Antz* in which she was the voice of Azteca.

With a burgeoning movie career under her belt, Lopez branched out into music at the same time as both Britney and Christina were battling it out for the title of 'Queen of Pop'. Her debut single 'If You Had My Love' came in 1999 and peaked at number four in the UK charts, although it reached number one in the US Billboard Hot 100.

Also new on the scene in the nineties were a slew of boy and girl bands, each battling with each other for musical

supremacy. Ironically, the popular boy band New Kids on the Block were now not so new on the block, having been around since 1984 with songs such as 'Please Don't Go Girl', but they paved the way for fresh acts like the Backstreet Boys ('I Want It That Way'), East 17 ('Stay Another Day'), Take That ('Back for Good'), Westlife ('Flying Without Wings') and Boyzone ('Baby Can I Hold You/Shooting Star').

The undoubted winners of the boy-band battle were the Mancunian masters of melody, Take That, who have gone on to achieve fifty number one singles internationally, have won eight Brit Awards and are considered to be the most successful boy band in UK chart history. Despite their successes the band, comprising Robbie Williams, Jason Orange, Gary Barlow, Mark Owen and Howard Donald, famously split in 1996, taking a break of nearly ten years before reuniting in 2005–06 and coming back with an even stronger sound than before.

During their hiatus, this gaping musical void was filled by their female counterparts, the Spice Girls, whose debut single 'Wannabe' hit the shelves in 1996 and catapulted them to immediate success with number one placements in thirty-seven countries around the world.

The video to accompany the hit song is one of the most recognisable and memorable – not to mention bizarre – of the nineties, featuring the five girls causing havoc in the St Pancras Grand Hotel in London. The music video begins with the girls causing a kerfuffle outside the hotel; Emma Bunton (Baby Spice) appears to steal a homeless man's baseball cap before the girls intimidate some arriving guests and then aggressively force their way into the hotel past the doorman. Once inside they assault an elderly man and throw his papers up in the air

before prancing and bouncing their way down the corridors, sexually harassing various guests along the way.

To the bemusement of onlookers, the girls perform an energetic dance routine on the main staircase before Melanie B (Scary Spice) and Baby Spice force themselves upon a few more unconsenting guests. Melanie C (Sporty Spice), meanwhile, jumps up on a dining table and does a backflip, just to show that she is worthy of her nickname, while Victoria Beckham née Adams (Posh Spice) appears to give a lap dance to a Catholic priest before Gerri Halliwell (Ginger Spice) knocks off his biretta for no good reason.

After a few more gyrations and rhythmic spasms, the girls flee the carnage they have created, past a couple of police officers interviewing the homeless man they robbed, and escape on a double-decker bus waiting outside that appears to be their getaway vehicle.

Because of this song and accompanying music video – or perhaps despite it – the girls went on to become a global phenomenon, leaving little room for competition within the girl-band genre. Other girl bands did emerge, and with some success, but none of them could compete with the might of the Spice Girls. Other UK and Irish girl groups at the time included B★Witched ('Blame it on the Weatherman'), Atomic Kitten ('Right Now') and All Saints ('Never Ever'), while from the US we got TLC ('Waterfalls'), Destiny's Child ('No, No, No') and En Vogue ('Don't Let Go').

As pop music continued to dominate the charts in the nineties, we also saw electronic music growing in mainstream popularity with dance music, house, techno, drum and bass and rave appearing in the charts. Dance music was huge in the

nineties and brought us hundreds of new songs from bands such as 2 Unlimited, SNAP!, Tony Di Bart, Robert Miles, Livin' Joy, Haddaway, Stereo MCs, C+C Music Factory and many others.

SNAP! famously gave us 'Rhythm is a Dancer', whose upbeat tempo, catchy melody and energising synth sounds were paired with sophisticated lyrics including the infamous line 'I'm serious as cancer when I say rhythm is a dancer'.

Tony Di Bart was most famous for his 1993 hit 'The Real Thing' which reached number one in the UK charts, and Robert Miles's song 'Children' spent thirteen consecutive weeks in the number one position of the Euro Top 100 chart.

Haddaway had us dancing to 'What is Love' and Rozalla got us singing to 'Everybody's Free (to Feel Good)'. And in 1993 we all joined in with Reel 2 Real's dance hit 'I Like to Move It', shouting out the 'Move It!' bit with no thought of the dancing lemurs that were to revive the song in the movie *Madagascar* some twelve years later.

Inexplicably, a lot of the dance music of the nineties came from Europe, and a whole new genre dubbed Europop emerged. Ace of Base, who were a Swedish group, churned out hits like 'All That She Wants', 'The Sign' and 'Don't Turn Around', while Dutch and Belgian band 2 Unlimited had a smash hit with 'No Limit' in 1993. Danish diva Whigfield had a one-hit wonder with 'Saturday Night' and Danish–Norwegian Eurodance group Aqua assaulted us with 'Barbie Girl', one of the most annoying songs ever made. Dutch popsters The Vengaboys lowered the tone further with 'Boom, Boom, Boom, Boom!!' and 'We're Going to Ibiza', and even the American-sounding novelty bluegrass song 'Cotton Eye Joe' was actually produced by a Swedish Eurodance group called Rednex.

Michael Jackson at the 1993 American Music Awards and a woman who looks a little bit like Jeffrey Tambor over his left shoulder.

As a companion to the dance music genre, the rave music scene invaded the charts from time to time with peculiar songs like 'A Trip to Trumpton' by Urban Hype, which followed a short-lived trend for sampling the music from children's TV shows and layering rave music over it. The first example was probably 'Summers Magic' by Mark Summers which used the theme tune from *The Magic Roundabout* and added a heavy rave drum beat. The Prodigy took the idea and ran with it, releasing 'Charly' a few months later – a rave song which sampled the soundtrack from the 'Charley Says' public information films from the seventies. And a little later came the pinnacle of peculiarity when The Smart E's released their rave mashup called 'Sesame's Treet' which I won't even take the time to explain since it is so self evident.

While the 'Toytown Techno' sub-genre, as it was sometimes known, was not taken particularly seriously, the rave scene itself was actually huge and in the UK the press frequently reported incidents of illegal raves taking place in farmers' fields where thousands of spaced-out ravers would spend the night dancing to high-speed rhythms and beeping sounds.

The ravers' ability to sustain the all-night rave sessions was frequently enhanced through the use of illegal drugs; the drug Ecstasy became particularly popular with both ravers and clubbers. In fact Ecstasy use became something of an epidemic in the nineties and, in contrast to the 'Just Say No' drug campaigns of the eighties, we now saw (or rather heard) positive reinforcement from rave band The Shamen with their 1992 song 'Ebeneezer Goode'.

Those who are familiar with the song will no doubt be aware of the thinly veiled drug references, particularly in the

chorus where they sing 'Eezer Goode, Eezer Goode, He's Ebeneezer Goode ...!'. Just to clarify, 'E' is the common nickname for Ecstasy so the chorus is actually saying 'E's are good ...'. The rest of the song lyrics are equally overt with lines such as 'E's sublime, E makes you feel fine', on one level talking about the eponymous character Ebeneezer Goode, while on another humorously promoting Ecstasy use.

The barely disguised Ecstasy encouragement in the song caused the BBC a headache when the track reached number one in the UK singles charts, since it naturally became a candidate for the family-friendly *Top of the Pops* TV show. The Shamen appeared on the show and sang their song without altering the lyrics relating to Ecstasy but bizarrely conceded to one very minor alteration relating to tobacco use. At the end of the song, singer (shouter) Mr C usually asks the question 'Got any salmon?' which is cockney rhyming slang – 'salmon and trout' for snout or tobacco. In the *Top of the Pops* version he instead asks 'Got any underlay?'. No one understood this cryptic allusion which resulted in accusations that it was yet another sneaky drug reference. However, Mr C later revealed that it was a gratuitous 'rug' reference!

The rave scene evolved and mutated in various forms during the nineties, leading to the development of a number of sub-genres including drum and bass, breakbeat, acid house, techno and jungle. While most of this music remained hidden away from the general public as something of a minority interest, from time to time songs from these genres would achieve a breakthrough in popularity and arrive in the mainstream charts, causing a musical shockwave due to their unique and extreme sounds like nothing else in the charts. One such

example was the 1994 song 'Incredible' from General Levy and M-Beat which was, for most people (me included), their first introduction to jungle music.

The high-speed drums and synthesiser background were reminiscent of rave music with enormous bass notes added which were practically sub-audible but could be felt shaking the room when I turned up the volume loud on my dad's hi-fi. On top of this was General Levy singing in a ragga style and making the strangest rhythmic screeching sounds like he was coughing up a fur ball interspersed with occasional shouts of 'Booyaka!'.

The lyrics were sung in a strong Jamaican patois and to a white teenage boy from a rural market town in Dorset, they didn't make a lot of sense. The first verse, for example, was:

> Well big up all the original junglist massive,
> The original dancehall junglist dere,
> General Levy alongside the M-Beat,
> The world is in trouble,
> Ah what we tell dem murdera
> It goes.

Which I think translates roughly as:

> Let's congratulate the first pioneers of the jungle genre,
> The very first of the nightclub jungle musicians,
> Mr Levy and his friend Mr Beat are here to perform for you now,
> And this music is going to be so good that it will figuratively shake up the whole world,
> We're going to show all those people who aren't very good at this genre how it should be done.
> And now we're ready to begin ...

To put this musical peculiarity into context, 'Incredible' reached number eight in the UK singles charts in September 1994 and was sandwiched between the moving ballad '7 Seconds' by Youssou N'Dour ft. Nehneh Cherry in ninth position and cheesy pop song 'I'll Make Love to You' by Boyz II Men in seventh position. There was nothing else even remotely like this in the charts at that time and this represented a significant breakthrough for the genre. Likewise, the increasingly piercing rhythmic whistling of the techno song 'Higher State of Consciousness' by Josh Wink in 1995 found favour with the masses and climbed up to number seven in the UK charts. These occasional glimpses of the underground music scene paved the way for mainstream acceptance of groups like The Prodigy and The Chemical Brothers.

Aside from the growth and evolution of electronic music, rock music was also undergoing something of a revolution as well in the nineties with the birth of a number of new sub-genres, each with their own distinctive sounds.

The Grunge movement of the US West Coast had been in gestation since the mid-eighties but it wasn't until the early nineties that it rose to mainstream popularity, largely through the influence of the band Nirvana. Other bands such as Alice in Chains, Pearl Jam and Stone Temple Pilots were also notable players in this genre but it was Nirvana's second album *Nevermind* from 1991 and, in particular, the track 'Smells Like Teen Spirit' which really defined the Grunge movement.

The album, with its iconic and much-imitated swimming baby artwork, went on to sell over 30 million copies and has been seen as a watershed moment in rock history that not only introduced us to Grunge music but also popularised alternative rock for the masses.

We also saw the arrival of crossover acts that took traditional rock music and combined it with elements of hip-hop, funk, dance music and other musical influences to create edgy new sounds.

Los Angeles-based funk-rock band Red Hot Chili Peppers hit us with a whole new sound in 1991 with their album *Blood Sugar Sex Magik*. Their first single 'Give It Away' was a huge, Grammy-winning success with funky, rhythmic guitar riffs, pounding drums and machine-gun-fire lyrics. Their second single 'Under the Bridge' in 1992 was an entirely different sound, a downbeat and melancholic ballad that reflected on the impact that narcotics had had on the life of vocalist Anthony Kiedis.

Despite a poor performance in the UK charts, reaching only thirteenth position, the song did well in the USA and took the number two spot in the US Billboard Hot 100. 'Under the Bridge' is considered to be one of the most important contributions to the alternative rock scene in the nineties and with its gritty subject matter and depressing nature it was an unusual choice of song for pretty popsters the All Saints to cover with their own version. Even more surprising is the fact that the All Saints' version of the song performed significantly better in the UK than the original, reaching the number one spot in 1998.

Alternative rock band Rage Against the Machine also surfaced in the nineties with a new brand of angry funk/rap metal fronted by dreadlocked, Californian revolutionary Zack de la Rocha. The band's self-titled debut album reached triple platinum status and featured such delightful ditties as 'Bullet in the Head' and 'Killing in the Name'. The latter of these songs was a huge success in 1993 and featured powerful, driving guitar, bass and drums picking up in intensity as the song progressed.

The anarchic lyrics are rapped and spat out with venom as a protest against police brutality following in the wake of the Rodney King beating by police in 1991.

The vitriolic ranting of frontman Zack reaches a crescendo of anger towards the end of the song and results in the repetition of the F-word some seventeen times as part of a repeating refrain. This caused something of an embarrassment for poor Bruno Brookes on 21 February 1993 when he accidentally played the full, uncensored song live on BBC Radio 1 during the Top 40 Countdown.

This is also the same song that a Facebook campaign urged people to buy in the run-up to Christmas 2009 to prevent yet another 'X Factor' Christmas song. The campaign was successful and 'Killing in the Name' goes down in history as the most anarchic Christmas song of all time.

While a lot of our rock music like Nirvana and Rage Against the Machine came from America, we had our own home-grown talent in the UK, although our style of rock was, in general, quite different from our US counterpart's. Pulp, for example, were an example of an indie-rock/Britpop band with a much less aggressive demeanour whose lyrics focused less on police brutality and more on mundane aspects of British life.

Their award-winning 1995 album *Different Class* reached number one in the UK album charts and featured tracks such as 'Common People' and 'Disco 2000', while their 1998 album *This is Hardcore* featured the classic 'Help the Aged', a song about being kind to old people that would have looked decidedly out of place on a Rage Against the Machine album.

Fellow alternative rockers and part of the Britpop collective were Suede, who had success with songs including 'Animal

Nitrate', 'We Are the Pigs' and 'Beautiful Ones'. All went well with Suede until 1994 when the bass guitarist, Bernard Butler, acrimoniously split from the band leaving a vacancy for a new guitarist. Rather bizarrely, I remember hearing, in a buzz of excitement at school, that Suede had found their replacement in none other than Richard Oakes, the kid who used to sit next to me in history lessons. It turned out that this unassuming school colleague, aged just 17, had sent a demo tape to the band when he heard they were auditioning and the band were so impressed with this that one of the band members thought they were actually hearing one of their own old demos. Consequently Suede offered the position to Richard who quit school there and then and became a rock star literally overnight.

Along with Pulp and Suede, the core of the Britpop movement comprised two other big-name alternative rock bands: Oasis and Blur. The two bands enjoyed a famous rivalry throughout the nineties, polarising their fans into two distinct camps.

Oasis released their album *Definitely Maybe* in 1994 which went straight to number one in the UK album charts and included such classics as 'Live Forever', 'Rock 'n' Roll Star', 'Supersonic' and 'Shakermaker'.

The anthemic heavy rock sound and sober lyrics of Oasis were contrasted with the perky, pop-rock sound and witty lyrics of Blur whose 1994 album *Parklife* included the hit singles 'Girls & Boys', 'End of a Century', 'Parklife' and 'To the End'.

The increasing tensions between the two bands led to the infamous 'Battle of Britpop' where Blur and Oasis both scheduled the release of their new songs on the same day in August

1995 to see who would secure the number one spot. Blur's 'Country House' took the top spot, selling 274,000 copies to Oasis' 216,000 for 'Roll With It', and led to Oasis frontman Noel Gallagher saying some pretty unpleasant things about Blur frontman Damon Albarn, for which he later issued a formal apology.

The Britpop genre also included bands such as Ocean Colour Scene, Kula Shaker, Supergrass, The Boo Radleys and The Divine Comedy, and even encompassed the entire Madchester scene comprising bands such as the Stone Roses, Inspiral Carpets, Happy Mondays and James.

The nineties also brought us some of the greatest music videos of all time thanks partly to the increasing popularity of the art form and also as a result of major developments in video production technology. One of the best examples of this can be seen in Michael Jackson's 'Black or White' video released in 1991, which begins with a cinematic camera swoop in from space, through a residential neighbourhood and in through the bedroom window of a young Macaulay Culkin (*Home Alone*) who is doing some serious air guitar moves to loud rock music in his bedroom.

George Wendt (*Cheers*), as his father, yells at him to turn the music off, to which the 11-year-old responds by placing some enormous, concert-style loudspeakers behind his dad as he watches TV. He cranks up the amplifier from 'Loud', past 'Louder' and up to the 'Are you nuts!?!' volume setting and then plays a power chord on his electric guitar that blasts his father out of the house, still in his armchair, into the sky and halfway across the world, landing eventually in the heart of Africa.

At this point the music starts and Michael Jackson begins dancing with a group of tribal African people, imitating and adapting their dance moves. From here Jackson seamlessly moves between different cultures, dancing with the various indigenous peoples and appropriating their traditional dance moves. He shifts from Thai dancing girls to Native Americans, Indians and Russian Cossack dancers before dancing solo to a background of KKK ritual footage which segues, with absurd juxtaposition, to a comical rap section in which Macaulay Culkin mimes the words and various other children strut and pose in gangsta/hip-hop style.

Jackson then starts dancing on the torch of the Statue of Liberty surrounded by various other international monuments, but it is the next section of the video that starts to get really interesting. By this point we have been lulled into a false sense of apathy when all of a sudden we see something that blows our minds. The video cuts to a head-and-shoulders shot of an unrobed asian man moving to the music who, after a few seconds, liquidly transforms before our eyes into an attractive black lady. Before we have realised what is happening, this lady seamlessly transitions into the form of a pale-skinned ginger lady who, seconds later, has become a bearded Caribbean man with dreadlocks.

At the time, this computer-generated imagery (CGI) was groundbreaking and shocking for most people who had never seen anything like it before. You have to remember that, until this point, special effects in films and TV shows were fairly unremarkable and the use of CGI was limited due to its cost and limitations.

For the first time we were presented with something where we really couldn't believe what our eyes were seeing. We knew

it wasn't real and yet what we saw defied our knowledge. To this day this sequence is still visually stunning and is historically significant as a turning point in the expectations and anticipation of the general public regarding special effects.

A few years later, we were treated to another epic music video production from Michael Jackson with his 1995 classic 'Earth Song' which was one of his many socially conscious songs encouraging peace, love and – in this case – harmony with the environment. The song was actually written and composed by Michael Jackson himself and was deliberately authored as a rhythmic ballad with a simple melody construct that would allow his fans to sing along easily.

When viewed without cynicism, the video is powerfully moving and features footage of deforestation of the rainforest, the carcasses of elephants cruelly slaughtered for their ivory, pollution pumped out of factory chimneys, war scenes and general destruction. The video was actually filmed in four different distinct regions, the first being the Amazon rainforest where, rather than using actors, the local Amazonians actually appeared in the video watching as the forest is cut down before them. Next the video cuts to a war zone in Croatia showing a village destroyed by gunfire and artillery bombardment. This time, actors are used for the villagers who pick their way through the rubble in dazed horror. The video then moves on to Tanzania where tribal Africans in traditional dress are seen looking on as illegal poachers destroy their habitat. The final filming location was New York state where a simulated forest fire is shown.

As the song picks up power through a sort of chanting chorus, the various characters in the video drop to their knees in despair and, as they hold the earth of the ground before

them, an apocalyptic event begins to take place as a powerful wind passes over the face of the earth and the world appears to be renewed and reborn with reverse footage showing fallen trees righting themselves and the slaughtered elephant growing new tusks and standing up; even a dead man is resurrected from the battlefield as the tanks and soldiers retreat.

Both the visual symbolism and the lyrics strongly hint at a religious perspective to the song, with the repeated 'Is there a time?' question reminiscent of Ecclesiastes 3:1–8 which talks of 'A time to love, and a time to hate; A time of war, and a time of peace'. The later lyrics also refer to Abraham of the Bible and the symbolism of the resurrected man and the heavenly power that restores the earth is a clear reference to Christian theology.

The video is certainly epic and in some ways cinematic, and, regardless of your perspective on Jackson, the sincerity of the video or the message within, it rightly deserves a place in history as one of the defining music videos of the nineties.

One last music video from Michael Jackson that is worth mentioning, also from 1995, is the ambitious production that accompanies the song 'Scream', an angry duet with his sister Janet Jackson. After having been on the receiving end of some rather negative press, Jackson responded with this aggressive little number which features a lot of screaming, moody pouting, a guitar-smashing scene, some explicit language and gestures (not heard in the radio edit of course) and a lot of anti-gravity solidarity with his sister.

At the time, the music video was one of the most expensive ever made at a cost of around $7 million and won numerous MTV Video Music Awards and a Grammy.

Also winning several MTV Video Music Awards was the video to accompany 'Virtual Insanity' by Jamiroquai in 1996.

Jay Kay, the novelty-hat-wearing lead singer of the popular acid-jazz/funk band arrives in the video standing on one leg and gliding towards the camera without moving. It takes a few seconds for the viewer to work out what is going on as Jay Kay suddenly whizzes backwards in what seems an impossible motion, and it's not until the furniture in the room begins to glide around as well that we realise that the floor itself is moving and the walls are stationary.

The resulting video, shot in a minimalist and futuristic room with the suggestion of a padded cell, gives Mr Kay the opportunity to strut, dance and glide to the music accompanied in his dancing occasionally by a cockroach and a raven. I'm not sure if there is any significance to the arrival of these supporting characters or to the fact that one of the sofas in the video begins leaking blood towards the end. All in all, the video is simultaneously fascinating, disturbing and confusing, and rightfully deserves to be considered an iconic music video of the nineties.

While some of the most memorable music videos rely on clever special effects to grab the attention of the viewer, in 1997, the Verve used a far simpler and much cheaper technique in the video to accompany 'Bittersweet Symphony'. Vocalist Richard Ashcroft is simply filmed in a continuous rear-view shot walking down a busy London pavement refusing to change his direction or stride as he repeatedly bumps into passers-by. Other than occasional close-ups of his feet in motion and the odd shot of an angry pedestrian, the video largely follows Ashcroft as he lip-syncs the song while walking along the pavement.

At one point, a car pulls in front of Ashcroft, blocking his path, and, without missing a step, he hops up on to the bonnet

and walks straight over it, much to the annoyance of the lady driver who rushes out and challenges him, to no avail. He just keeps walking and shows no reaction to any of the circumstances around him, even knocking a lady to the floor at one point without flinching. The resulting footage is really quite remarkable and, while it was scripted and used actors, it actually feels very realistic and uncomfortable.

The video was directed by Walter A. Stern and was conceived as an homage to the music video for Massive Attack's 'Unfinished Sympathy' from 1991, which filmed vocalist Shara Nelson walking down a busy street in Los Angeles. In the Massive Attack video, Nelson does not shoulder-barge any people out of the way, nor does she climb on any cars, but what makes this video particularly interesting is that it is filmed as a single continuous shot for nearly five minutes. It's highly unusual and technically very difficult to film a single continuous shot for that long without something going wrong, and it's certainly a technical masterpiece if not quite as visually exciting as the Verve's version.

In the Massive Attack video, a lot of actors and extras were used but a number of the people seen in the background on the street are actually locals who simply refused to get off the pavement while they were filming, adding a little touch of authenticity to the proceedings.

Walter Stern also directed the music video for Massive Attack's follow-up hit in 1998, 'Teardrop', taking quite a different approach this time. As the song plays, a camera pans around inside a CGI environment meant to be a womb. This reveals an unborn baby who ultimately opens its eyes and begins lip-syncing the words of the song. The effect is more disturbing than comical but in either case it is certainly memorable.

As well as providing us with music videos to accompany our favourite songs, the television brought us new music through a different medium: the advert. While there had long been a marriage between popular music and marketing, the product was always the star and the music was just the accompaniment, but this began to change in the nineties when we saw a number of adverts appear where the soundtrack was so good that it became far more memorable than the actual product. I doubt the advertisers were too concerned by this, since the popularity of the music would inevitably create a positive association with the actual product that was being advertised.

Probably the best example of this came from the good people at Levi's who first introduced us to the song 'Spaceman' by Babylon Zoo. The one-minute advert is heavily reliant on the electro-rock soundtrack as it tells the story of a futuristic teenage girl arriving home late, in her spaceship (of course), flaunting a well-fitting pair of Levi's, much to the horror and disapproval of her fuddy-duddy parents and neighbours. Those of us who actually bought the full version of the song were sorely disappointed to discover that, after a few bars of the familiar funky electro-rock number, the song suddenly changes into a dreary heavy rock dirge nothing like the bit that we actually liked.

Levi's did it again in 1999 with the bizarre and amusing 'Flat Eric' video and the house music track 'Flat Beat' by Mr Oizo. The video features two friends in a car listening to the aforementioned music on the radio and shows them getting pulled over by a traffic cop who checks their IDs and looks in the trunk of the car which is full of neatly arranged Levi's clothing. Of course, one of these two friends is a furry yellow muppet-like character called Flat Eric who drives along with his arm out of the window bopping his head to the music.

In this example the advert was for Levi's Sta-Prest range of clothing that had a sharp crease in the trousers and shirt sleeves, but all we saw was a cute and cool puppet character and we heard an even cooler soundtrack. Apparently the marketing team at Levi's were concerned about this advert after early audience research didn't look promising, but decided to go ahead and release it anyway. The result was an unexpected success – for Mr Oizo the musician, anyway, who ended up selling millions of copies of the single which spent two weeks at number one in the charts.

It wasn't just Levi's whose adverts were overshadowed by the success of their soundtracks: in 1993 VW got a taste of this phenomenon too when their mildly amusing and very forgettable advert for a VW Golf GTI surprisingly led to the soundtrack hitting number one in the charts for four weeks. The song in question was 'Young at Heart' performed by The Bluebells and originally co-written and recorded by Siobhan Fahey of Bananarama. The Bluebells had been a relatively small-time band with limited success who split up in the mid-eighties but, much to their surprise, they experienced a revival as a result of the advert and even re-formed temporarily to sing the song on *Top of the Pops*.

Despite the nineties producing some of the most talented bands, anthemic songs and a wealth of new musical genres, the great British public still liked to indulge itself in ridiculous novelty songs from time to time. There's something in the British psyche that seems to compel us, periodically, to abandon our senses and spend our hard-earned money on these embarrassing aberrations, much to the consternation of our level-headed American counterparts.

Back in the eighties, we had seen classics like Spitting Image's 'Chicken Song' and Black Lace's 'Agadoo' storming the charts, and so it came as no real surprise when Timmy Mallet kicked off the silliness in 1990 with his now infamous song 'Itsy Bitsy Teenie Weenie Yellow Polka Dot Bikini', which spent an amazing three weeks at the number one spot in the charts. Prior to his induction into the Pop Music Hall of Shame, Timmy Mallet was best known as the presenter of 'Mallet's Mallet', a segment on *Wacaday* that involved hitting children over the head with a giant (foam) mallet with Timmy occasionally uttering his witty and cerebral catchphrase 'Blaaah!'.

Shortly after this, in 1991, we were treated to the dubious pleasure of Hale and Pace with their Comic Relief charity single 'The Stonk', in which they tried unsuccessfully to introduce a new dance craze to the nation. Despite their failure to enrich us with a memorable dance routine, the song did reach number one in the charts briefly and raised an estimated £100,000 for charity. Through the supportive avenue of Comic Relief, Hale and Pace had enough influence to persuade Queen's Brian May to join them in the music video, alongside Pink Floyd's David Gilmour and Black Sabbath's Tony Iommi. On the drums was Rowan Atkinson as his character Mr Bean.

Next up was Right Said Fred with their debut single 'I'm Too Sexy'. I don't think it was actually meant to be a novelty song but it fit the necessary criteria of silliness and featured bald-headed brothers Fred and Richard Fairbrass strutting up and down a catwalk in leather trousers and fishnet vests, flexing their muscles at the camera.

A more conventional novelty song, if there can be such a thing, came next with 'Mr Blobby', an eponymously titled track from Mr Blobby himself. The clumsy pink-and-yellow-

Fashion icon and musician Madonna wearing considerably more clothes than usual at a concert in London, 1993.

spotted character departed from his usual confines on the set of *Noel's House Party* and had his own song and music video which featured the likes of a young Jeremy Clarkson (with full mullet hairdo), Carol Vorderman – who was still presenting *Countdown* with Richard Whiteley at the time – and of course Noel Edmonds himself. The song actually knocked Meatloaf's 'I'd Do Anything For Love (But I Won't Do That)' off the number one spot in the UK charts – a position Meatloaf had enjoyed for the last seven weeks. The victory was short-lived, though, since Take That claimed the top spot just a week later with their single 'Babe'. In a remarkable turn of events, the following week Mr Blobby reclaimed the number one position from Take That, winning the coveted Christmas Day number

one spot in 1993 and ruining every Christmas compilation album that came thereafter.

The Americans never really embraced novelty songs like we did in the UK, but they did contribute, in some small way, with 'Turtle Power' by Partners in Kryme, a US hip-hop duo from New York City. The song was the soundtrack to the Teenage Mutant Ninja Turtles movie from 1990 and we Brits needed no encouragement when we saw a novelty song in need of support. We rushed out and bought the single in such volume that it reached the number one position in the UK and stayed there for four weeks, while in America the song languished in the charts, reaching a miserable peak position of just number thirteen.

The nonsense continued throughout the decade with regular episodes of musical insanity supplanting all common sense and reason. In 1997 we reached the epitome of bad taste when 'Teletubbies Say "Eh-Oh!"' by the Teletubbies spent two weeks at the number one spot. We had crossed a line and we knew it. With a contrite heart, the British people vowed never to let things go this far again, and over the remainder of the decade we let the admonishing words of the Manic Street Preachers' 'If You Tolerate This Your Children Will Be Next' remind us of the dangers of novelty songs.

While a lot of terrible music surfaced in this decade, the truth is that the nineties were actually a time of significant musical innovation, giving rise to some of the most talented musicians and birthing an astounding variety of awesome music that pushed the boundaries of traditional pop music completely out of sight.

We saw the development and maturity of electronic music and alternative rock, we discovered whole new genres of music

that never even existed before and we watched music videos become cinematic masterpieces.

We became the generation that sang along to 'Mysterious Girl' by Peter Andre, did the dance to 'U Can't Touch This' by MC Hammer and remember when Ant and Dec were PJ and Duncan singing 'Let's Get Ready to Rhumble'.

And, what is more, we were the children of the nineties who got to conclude this musical decade by actually partying to Prince's song '1999' on New Year's Eve in 1999, singing together, 'So tonight I'm going to party like it's 1999! (Which it actually is!)'.

Four

TV SHOWS

Nothing can beat that feeling of waking up on a sunny Saturday morning as a young child knowing that there's no school today, knowing that your mum and dad are going to have a lie-in while you and your brothers get up and watch *Live and Kicking* or *SM:tv Live*, still dressed in your Teenage Mutant Ninja Turtle pyjamas, savouring the knowledge that, no matter how glorious the sunshine outside may be, you are going stay inside, close the blinds and cram in as much television viewing as you possibly can.

You know that, as well as the gluttonous visual feast of Saturday morning children's television spread before you, you will later be allowed to gorge on the Saturday evening television entertainment, including *Noel's House Party*, *The Generation Game* and *Gladiators*.

For many of us, this was a typical Saturday morning scenario. We would perch on the sofa watching TV and munching our sugary bowl of Cheerios or Lucky Charms, occasionally spraying out a fine mist of breakfast cereal from both mouth and nose as we laughed hysterically at the antics of comedy duo

Trevor and Simon on *Live and Kicking*. Those who are slightly older will remember that Andi Peters and Emma Forbes were the original hosts of *Live and Kicking*, but they were later replaced by the more memorable pairing of Jamie Theakston and Zoë Ball. The respective hosts were joined each week by numerous characters, including the aforementioned Trevor and Simon, whose bizarre brand of comedy appealed to children and adults alike; a pair of puppet leprechauns called Sage and Onion; and of course Mr Blobby, who had his own game on the show called 'Blobby's Baggage' for which viewers had to guess where Mr Blobby had been on his holidays.

While *Live and Kicking* was the dominant children's programme on Saturday mornings for most of the nineties, towards the end of the decade the BBC faced a bold new competitor from the studios of ITV in the shape of *SM:tv Live*, hosted by a very young and over-excited Ant and Dec and Cat Deeley.

The show was so successful that it actually led to the demise of *Live and Kicking* entirely and became ITV's most successful children's programme since *Tiswas* with Chris Tarrant in the seventies.

While similar in style and format to *Live and Kicking*, *SM:tv Live* won the ratings battles hands down, partly due to its inclusion of the extremely popular 'Pokémon' cartoon series but largely because of the cheeky antics of Ant and Dec, whose presenting style appealed to a very broad age range. In fact, looking back at old episodes of the show as an adult, it can be quite shocking to realise just how much thinly veiled innuendo there was that completely went over the heads of the younger audience.

One of the most memorable recurring games on the show was 'Wonkey Donkey', which was essentially a rhyming version of *Catchphrase*. At the introduction to the game a stuffed three-legged donkey was shown as the example and Dec would rapidly explain, 'I've got a donkey that's gone all wonkey, look his leg's missing! You've got to tell us what the animal is and what's up with it. It's got to rhyme though!'

The viewers would then be shown a stuffed animal in some kind of costume or props, and then phone-in contestants would have ten seconds each to guess what the rhyming name of the animal was. As an example, one of the animals in question was a plush crocodile wearing a kilt and tartan hat, and despite the primary rule that names must rhyme, contestants would usually get stressed by the ten-second countdown and blurt out the weirdest non-rhyming nonsense, which made the game all the funnier. In this case, pressure-fuelled guesses included poor attempts such as 'Scottish Alligator' and 'Scottish Crocodile', which had Dec angrily shouting and gesticulating into the camera in mock frustration, reminding the contestant that it had to rhyme. Eventually someone got the right answer which was, of course, 'Jock Croc'!

Prior to hosting *SM:tv Live*, Ant and Dec were better known to us as PJ and Duncan – their respective character names in the serial teen drama *Byker Grove*. It was while filming *Byker Grove* that Ant and Dec first met and formed their lasting friendship. *Byker Grove* was set in a youth club in the Byker district of Newcastle and featured some fairly hard-hitting and controversial storylines covering topics such as drug use, sexuality, crime and even the deaths of a number of characters.

After leaving *Byker Grove*, Ant and Dec turned their attention to their relatively short-lived music career, in which

they performed under their Byker names, PJ and Duncan. Their most famous song was, of course, 'Let's Get Ready to Rhumble' from the album *Psyche*.

In the previous decade, children's television programming was strictly limited to specific time slots on the three or four channels available to most people (BBC1, BBC2, ITV and, from 1982, Channel 4). But the children of the nineties were the first generation to benefit from the growing availability of satellite and cable television that gave us access to around-the-clock children's television and dedicated kids' TV channels, such as Nickelodeon which arrived in the UK in 1993.

The rapid proliferation of new TV channels and networks also led to an increase in the availability of American children's shows in the UK, including the *Teenage Mutant Ninja (Hero) Turtles*, *Mighty Morphin Power Rangers*, *Barney the Dinosaur*, *Bear in the Big Blue House*, *Rugrats*, *Saved by the Bell* and *The Simpsons* – though I'm not sure the latter is truly a children's programme!

All this was on top of existing British TV programmes which included classics such as *Brum*, *Pingu*, *Superted*, *Art Attack*, *Postman Pat*, *Count Duckula*, *Rosie and Jim*, *Bananaman*, *How2*, *Come Outside*, *Blue Peter* and, my own personal favourite, *ChuckleVision*.

ChuckleVision featured the once-seen-never-forgotten fraternal comedy duo Barry and Paul Chuckle (real names Barry and Paul Elliott), who in each episode would undertake a fairly simple task that would always end in disaster. The pair would often travel around in their 'Chuckmobile', which was a quad-racycle with the registration plate CHUCKLE 1.

The slapstick humour and dim-wittedness reminiscent of Laurel and Hardy was accompanied by numerous catchphrases,

including the famous 'To me' 'To you' and 'Oh dear ... oh dear, oh dear', which were perfect for playground imitation. The simple plotlines, witty dialogue and physical humour led to tremendous success for the bumbling brothers, who ultimately recorded 292 episodes of the show.

One of my favourite lines from the show comes from an episode where Barry and Paul Chuckle are walking along the banks of a canal. Paul says to Barry, 'It's amazing to think that these canals were all dug by hand.' To which Barry replies, 'Why? Did they not have shovels back then?' Paul turns to him with a look of condescension and says, 'Of course they had shovels! They just preferred to use their hands!'

While there were a lot of well-made, engaging and entertaining children's programmes in the nineties, there were also some terrible, mind-numbing and downright weird shows, such as the infamous *Teletubbies*, which first appeared on our screens in 1997. The four characters, Tinky Winky, Dipsy, Laa-Laa and Po, were peculiar creatures who looked a bit like a cross between a teddy bear and a nightmare, who talked in a gibberish language and had television screens in their bellies. Their infamy came in part from the critical reception they received from some people who claimed that their nonsense talk could adversely affect normal speech development in infants.

Additionally there was some controversy surrounding Tinky Winky's handbag, since the character was supposedly male and his carrying a bag led to speculation that the character might actually be a subtle way of including a subversive element of homosexuality in the show. Further evidence to support this claim was the character's purple colour and triangular-shaped antenna on his head, which are both, apparently, symbols of the gay pride movement.

The Chuckle Brothers: Paul Chuckle (left) and Barry Chuckle (right). The source of much silliness and laughter for many nineties children.

Aside from this, the show was really quite bizarre, dream-like and somewhat psychedelic. From time to time a Magic Windmill in Teletubbyland would begin spinning and make a sinister whooshing sound which would lead to the television screens on the bellies of the Teletubbies lighting up and show-ing a live TV segment involving real children playing. At the end of the short video, the Teletubbies would all shout, 'Again! Again!' and the video would be played again. At the end of the show the 'Voice Trumpets' would announce that it was 'Time for Tubby Bye-Bye' and the Teletubbies would reluctantly return to their home in the Tubbytronic Superdome as the

sun, with a superimposed face of a chuckling baby, set below the horizon.

Despite its disturbing nature and nightmarish qualities, the show somehow became incredibly popular (subliminal mind control perhaps?) and even led to a variation of the theme song being released as a single called 'Teletubbies say "Eh-Oh!"', which reached number one in the UK singles chart in December 1997.

Of course there was much more than just children's TV available for us to watch, and no discussion of nineties TV would be complete without remembering that classic game-show *Supermarket Sweep*, hosted by the perma-tanned and very camp Dale Winton, who always tucked his T-shirt into his trousers. First aired in 1993, the show was set inside a studio mock-up of a very eighties-looking supermarket where three teams of badly dressed contestants each had to answer questions and riddles and play games to earn time on the clock for their trolley dashing.

Having observed the antics of the contestants, it seems evident that there is something coded into the DNA of all humans at a deep and primeval level that turns them into savage and wild animals during a trolley dash. Previously quiet and respectable ladies would suddenly turn into monsters on a rampage as they raced around the aisles sweeping as much as they could fit into the shopping trolleys while simultaneously screaming with uncontrollable joy/trolley rage.

The excitement seemed a little disproportionate when you considered that the prize fund was actually a measly £2,000, especially compared to the £1 million jackpot that was being given away by another ITV gameshow that arrived in the nineties, *Who Wants to Be a Millionaire?*. Chris Tarrant hosted this

popular gameshow, in which a single contestant would answer a series of increasingly difficult questions with proportional cash rewards in the hope of winning the million-pound jackpot. Few ever made it to the jackpot since the later questions in the show were always ridiculously difficult, but over the course of the show's 592 episodes, six people did actually win the million-pound prize. One of these was Charles Ingram, who later had to return the money after it was discovered that he cheated and used an accomplice in the audience who would cough strategically to indicate the correct answers.

It wasn't all about the money, though, as the many other gameshows of the decade proved. In fact, in the Saturday night favourite *You Bet!*, the prize fund was entirely donated to charity. Bruce Forsyth was the original host of the show from 1998 to 1990, before being replaced by the towering 6-foot 5-inch Matthew Kelly from 1991 to 1995 and finally the all-singing, all-dancing Darren Day from 1996 to 1997. The format of the show was simple: a panel of celebrities would place bets on whether or not a member of the public would be able to achieve an unusual activity or stunt for which they had been given some training and rehearsal within a limited time frame. If they won the bet, they would be awarded points that would be converted to pounds at the end of the show and then donated to the charity of the celebrity panellist's choice.

Many of the celebrity panellists were well known at the time but have either now died or disappeared into obscurity. They included Geoff Capes (the strongman), Mr Motivator (the fitness instructor from *GMTV* who looked a bit like MC Hammer), Terry Christian (presenter of *The Word*), Michael Fish (hurricane-denying weather forecaster), Paul Shane (Ted from *Hi-De-Hi*) and Bob Carolgees (Spit the Dog).

One of the more memorable challenges of the show involved a team of eleven men trying to pull 143 tonnes of London Underground train and carriages a distance of 250 feet in under three minutes. They made a valiant attempt but failed the challenge when they were just a metre from the finish line. Another London Underground challenge involved an 8-year-old boy memorising the London Underground map and then successfully identifying twenty small sections of the map with the station names and line colours removed.

Some of the challenges were seriously impressive feats of skill or memory, and others were nail-biting as the contestant raced against the clock, but none of them were quite so disappointing as the time when 18-year-old Lynnette Jones from Mitcham in Surrey said she could identify twenty-five of the regular characters from the TV show *The Bill* in two and a half minutes by just being shown a small portion of their faces. After a tremendous build-up, poor Lynette failed the challenge after just twenty seconds by incorrectly identifying DC Jim Carver's left ear.

During Matthew Kelly's tenure hosting *You Bet!* he was rather suddenly and unexpectedly asked to take over the presenting role of another iconic ITV entertainment show, *Stars in Their Eyes*, which was usually hosted by much-loved TV presenter Leslie Crowther. Tragically, Crowther's TV career had been cut short in an instant as the result of a near-fatal car accident which left him in a coma for seventeen days and hospitalised for a good deal longer. While he returned to our television screens just over a year after the accident, he never fully resumed his career and retired from show business in 1994, just two years before his death aged 63.

Stars in Their Eyes was a talent show in which members of the public impersonated famous singers, after which the studio audience would vote for their favourite act. Each impersonator would be introduced through a little video vignette which gave an overview of their day-to-day lives and a few clues as to who they were going to be. Back in the studio, the plain-clothed contestant would then reveal their alter-ego with the immortal words, 'Tonight Matthew, I'm going to be ... Dolly Parton!', or whoever they happened to be imitating. We would then watch the recognisably costumed and heavily made-up impersonator walk on to the stage through a cloud of theatrical smoke and begin singing their song of choice, sometimes startling us with the likeness they bore to the original act.

Arguably the most memorable episode was the 1999 final which saw Ian Moor from Hull win as Chris de Burgh. During his performance of 'Lady in Red' he was much surprised when he was joined on stage by the real Chris de Burgh, who performed the song as a duet with him.

Hosts Matthew Kelly and Leslie Crowther also had another TV show in common that they appeared on at different times in their careers: *This Is Your Life*, the biographical documentary show that surprised celebrities and notable persons with a televised account of their life. Originally hosted by Eammon Andrews and later by Michael Aspel, the long-running TV show would begin with an undercover operation to surprise the guest of the show as they went about their business. Often the surprise would take place during some kind of show where the guest was performing, and Michael Aspel would come up with ingenious ways of sneaking up on them and catching them off guard, before presenting them with the famous red book emblazoned with the words

'This Is Your Life', while simultaneously saying the very same words.

The rest of the show was filmed in a studio where the guest and their family would be seated while Michael Aspel read from the red book to give a potted account of their life story. The story would be interspersed with photos and video clips and then, at several points throughout the show, the disembodied voice of a friend or relative would be heard relating a short memory of the guest before they made a surprise appearance in the studio.

Guests on the show included actors, singers, comedians and sports personalities; even the less famous were honoured – charity workers, business people, clergy. Most of the episodes went off without a hitch but sometimes the surprise element caused a few problems. In 1990, comedian Ernie Wise was surprised with the big red book and later explained that he had actually seen his cousin, who was there for the surprise show, in the toilets at the BBC Television Centre earlier but thought he must have imagined it! Comedy actor Ronnie Barker's surprise with the big red book was spoiled after he stumbled across a piece of paper at his house with the name Brian on it and a telephone number. Convinced his wife was having an affair, he phoned the number and discovered the truth, but the show had to be cancelled after the surprise was ruined. And in an early episode of the show, Spike Milligan spotted a researcher parked outside his house and, thinking it suspicious, called the police and told them it was a suspected stalker. The police actually arrested the researcher, who was briefly jailed pending enquiries!

First airing in 1955, the show was inspired by the success of an American TV show of the same name, and the UK

version of *This Is Your Life* ran for forty-three series, with a total of 1,130 episodes over nearly fifty years.

One of the many 'victims' of the show was legendary prankster Jeremy Beadle, whose appearance in 1994 came between series eight and nine of the hidden camera show *Beadle's About*. He was honoured for his contribution to the entertainment industry, which began in the 1970s and included writing for and presenting numerous TV and radio shows, but it is for his practical joking that he will always be most fondly remembered.

Beadle's About ran from 1986 until 1996, with ninety-four episodes shown during that period; each show was a collection of practical jokes played on unsuspecting members of the public and filmed with hidden cameras. The jokes were, at times, quite elaborate and involved numerous actors, props and careful planning to execute.

One of the most memorable pranks took place at The Dockland's Sailing Centre in London, where unsuspecting market trader Dave Hughes parked his white van, containing his entire livelihood, on the edge of the dock. While Dave and his friend went to lunch nearby, the production team quickly moved Dave's white van out of sight and replaced it with an identical van as the set-up for the prank.

As Dave returned from lunch he was just in time to see a large crane 'accidentally' push his van over the edge of the dock and into the water, where it promptly sank, leaving nothing but a stream of bubbles in its place. On witnessing this, poor Dave could do nothing but watch in horror and scream 'NO!' repeatedly at the top of his voice, sinking to his knees in dismay. As if the prank hadn't been painful enough for traumatised Dave, actors pretending to be the crane driver and dock

The exterior of Father Ted's parochial house on the fictional Craggy Island. All the interior shots were filmed in a studio.

manager then proceeded to wind Dave up further by telling him that he needed to get the van moved from there ASAP and that he shouldn't have been parked there in the first place.

Just before Dave had a full-blown meltdown, a scuba diver surfaced in the water calling out, 'Who dropped a van on my head?' before climbing out of the water to accost Dave. As the diver removed his headgear, a relieved Dave recognised the grinning bearded visage of none other than Jeremy Beadle PE (Prankmeister Extraordinaire).

Perhaps the most daring and successful of all the pranks, though, involved unsuspecting Janet Elford from Dorset, who was tricked into believing that aliens had landed in her back garden. The poor deluded woman ended up making a fool of

herself on national television by singing to the aliens and offering the extraterrestrial visitors a nice cup of tea.

While the pranks generally worked as expected, there were occasional backfires and in one memorable case several of the actors and Mr Beadle himself were physically attacked after angry Londoner Vincent Spiteri was tricked into believing that part of his house was being turned into a lorry park.

We were truly spoiled for choice with light entertainment television in the nineties and in many ways this was its golden era. There were dozens and dozens of gameshows and family challenge shows, including old favourites *Gladiators*, *Countdown*, *The Generation Game*, *Challenge Anneka*, *Telly Addicts*, *Through the Keyhole*, *The Krypton Factor*, *The Crystal Maze*, *Knightmare*, *Robot Wars* and *Scrapheap Challenge*. We also had general entertainment shows like *Noel's House Party*, *Blind Date*, *Surprise Surprise*, *Top of the Pops*, *The Clothes Show*, *Changing Rooms* and many more.

Traditional soap operas like *Coronation Street* and *Eastenders* that had already been running for years were joined in the nineties by some new upstarts, including the ill-fated *Eldorado*, a BBC soap opera experiment which was set on the Costa del Sol in Spain and followed the lives of a group of ex-pats living there. Despite an enormous marketing campaign and high production cost, the soap was a disaster and lasted just one year before being scrapped.

Teen soap opera *Hollyoaks* was more successful, first airing in 1995 and developing a strong following almost straight away. Originally the show was a slow-paced, mild and humorous drama about a group of seven major characters living in a suburb of Chester called Hollyoaks. Over time, though, the storylines became heavier, darker and more controversial, and

the original characters left one by one. In fact, at the time of writing, only one of the original cast remains: Nick Pickard, who has played Tony Hutchinson since the very first episode.

The darkening of the storylines was a common theme among all the soap operas and a competition arose between them to see who could come up with the most controversial content and win the highest ratings. *Emmerdale Farm* was one of those competitors and made a deliberate move to shrug off its parochial image by first changing its name to just *Emmerdale* and then staging one of the most explosive (literally) storylines in soap opera history.

On 30 December 1993, viewers of *Emmerdale* were shocked and enthralled by the 'Beckindale Air Disaster' episode, in which a large commercial jet aircraft crashed into the village of Beckindale, in a manner reminiscent of the Lockerbie disaster of 1988, killing several of the villagers and destroying many of the buildings. The plot device was an opportunity to shake up the staid image of the show while simultaneously pruning the cast list and creating opportunities for new characters to enter. As with any controversial storyline, there were numerous complaints and in this case the proximity of the date the episode was shown to the fifth anniversary of the Lockerbie plane crash was deemed particularly insensitive.

In addition to the growing list of British and international soap operas available to us, we were also introduced to a variety of new dramas, including slow-moving sixties police series *Heartbeat* and slow-moving Northern Irish drama *Ballykissangel*, both of which were most popular with the slow-moving older generation. For those who preferred a little more spice in their dramas, there was the popular comedy-drama *Cold Feet*, which followed the lives of three couples as they tried to navigate the

rocky path of romantic relationships, and military drama *Soldier Soldier*, which led to the unfortunate formation of pop duo Robson and Jerome, who had been primary actors in the series but left to take up a musical career targeted mainly towards hormonally-imbalanced middle-aged women.

The nineties also treated us to the lavish LWT (London Weekend Television) production of *Agatha Christie's Poirot* in which David Suchet played the famous Belgian detective in a series that ran for seventy episodes until 2013. The BBC's response was to create their own detective drama, *Jonathan Creek*, which saw Alan Davies take on the role of a designer of illusions for stage magicians who uses his lateral thinking skills to solve criminal mysteries while assisted by his less perceptive sidekick Caroline Quentin.

Old favourite serial dramas *Casualty* and *The Bill* continued to be shown throughout the decade, competing with brand new drama from America which included *Baywatch*, *Twin Peaks*, *Sex and the City*, *Ally McBeal*, *ER*, *Beverley Hills 90210* and *The X-Files*. Canada also contributed to our viewing with crime drama *Due South*, featuring the exceptionally polite Constable Benton Fraser fighting crime in his dashing red Mountie's uniform with support from his canine sidekick Diefenbaker. Also from Canada was moody teen drama *Dawson's Creek*, which featured a very young Katie Holmes in her pre-Tom Cruise days. As well as continuing to entertain us with *Neighbours* and *Home and Away*, Australia gave us a new high-school drama with *Heartbreak High*, which followed the lives of a group of – mostly troubled – students at Hartley High School in a tough suburb of Sydney.

In addition to copious amounts of drama, soap operas, gameshows and children's television, a whole new genre of TV

programming aimed squarely at Generations X and Y began to emerge in the nineties in the shape of irreverent alternative programmes such as *Eurotrash*, *The Word*, *TFI Friday*, *Don't Forget Your Toothbrush* and *The Big Breakfast*.

Prior to the arrival of *The Big Breakfast*, morning television had been a rather staid affair: the liveliest option available was *Good Morning Britain* with presenters Anne Diamond and Nick Owen sporting cosy, knitted sweaters and talking patronisingly to viewers in a manner reminiscent of a nurse talking to an elderly patient. All this changed, though, at seven in the morning on 28 September 1992, when Chris Evans and Gaby Roslin burst on to our screens with unnatural enthusiasm and energy for a Monday morning and welcomed us to the first ever episode of *The Big Breakfast*.

The noisy and brightly coloured show was filled with silly games, jokes, light-hearted interviews and general nonsense aimed at entertaining the younger generations before their departure to school or the office. Older generations accidentally tuning in to the show likely spluttered into their bowl of bran flakes in disgust, but the show remained popular with a large demographic throughout its twenty years on air.

One of the most memorable features on the show was the 'On the Bed' section, where Paula Yates, the wife of Bob Geldof (whose company produced the show), conducted informal interviews with celebrities while reclining with them on a large bed. Interviewees on the bed included stars such as Keanu Reeves, Robin Williams, Yasmin Le Bon, John Lydon, Robert Plant and many more, but of all the interviews, that with Michael Hutchence is by far the most infamous. During the interview, the couple openly flirted with each other in this prelude to their affair, which took place shortly afterwards.

During the whole interview Paula and Michael's legs were entwined together and the couple gazed amorously into each other's eyes while exchanging innuendo-laden banter in an almost public declaration of their intentions.

Also on the show were Zig and Zag, the loud-mouthed furry alien puppets from the planet Zog whose popularity led to them releasing a number of records, including the memorable 'Them Girls, Them Girls', which reached number five in the UK charts. Every episode included an eclectic assortment of increasingly ridiculous games, such as 'Bowl the Vole', 'Spot the Sausage', 'Wheel of Fish' and 'What's in my Pants?'.

After leaving *The Big Breakfast*, Chris Evans went on to host the equally light-hearted *Don't Forget Your Toothbrush* and then the more popular *TFI Friday*, which featured live music, celebrity interviews and bizarre games such as 'Freak or Unique', where guests would come on to the show and perform some kind of hideous talent like squirting milk out of their eyes.

Another popular game on the show was 'Baby Left or Baby Right' in which a baby would be filmed sitting upright for a few seconds before toppling to one side on a cushion and then a celebrity guest would have to guess which way they would fall. My own favourite feature on the show was a section called 'Fat Lookalikes' in which people would be invited on the show each week who looked like overweight versions of popular celebrities!

In the nineties, we also saw a huge amount of new comedy talent on the television with dozens of new sitcoms and sketch shows including the hugely popular *The Fast Show*, which first aired in 1994 and starred Paul Whitehouse, Charlie Higson, John Thomson, Caroline Aherne, Arabella Weir, Mark Williams and Simon Day.

The Fast Show was arguably the most influential sketch show of the decade and introduced us to such memorable characters as Bob Fleming, the TV host with the persistent cough, Johnny the artist who has a terrible reaction to the word 'black', and Ken and Kenneth, the tailors whose catchphrase is 'Ooh! Suits you sir!'. Then there was the wonderful Rowley Birkin QC, played by Paul Whitehouse, who tells unintelligible rambling anecdotes by the fireside, punctuated occasionally with odd snippets of clear speech, such as '... her husband had been entombed in ice ...' or '... the whole thing was made completely out of rubber ...'

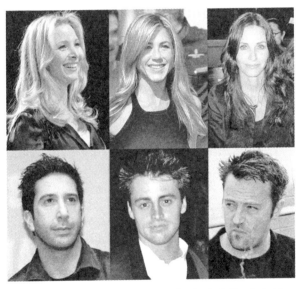

The friends from *Friends* (clockwise from top left): Phoebe Buffay, Rachel Green, Monica Geller, Chandler Bing, Joey Tribbiani and Ross Geller.

Rival sketch show *Smack the Pony* surfaced towards the end of the decade starring Sally Philips, Doon Mackichan and Fiona Allen, with characters such as 'The Clingy Ex', who is shown each episode clinging to the leg of her ex-boyfriend wherever he goes, telling him she is still in love with him, and the 'High-Heeled Woman', who wears high heels wherever she goes and whatever she is doing, even while surfing!

Sitcoms in the nineties included the continuation of classics like *Only Fools and Horses*, *Red Dwarf*, *Birds of a Feather* and *'Allo 'Allo* but also introduced us to brand new comedy with *Keeping Up Appearances*, *The Brittas Empire*, *Absolutely Fabulous*, *The Vicar of Dibley*, *Men Behaving Badly*, *Bottom*, *The Thin Blue Line*, *Drop the Dead Donkey* and *The Royle Family*, among others.

We also saw the arrival of *One Foot in the Grave* in 1990, with Victor Meldrew and his immortal catchphrase 'I don't believe it!', and the wonderful *Father Ted* in 1995, written by Graham Linehan, who also went on to write *Black Books* and *The IT Crowd*.

The premise behind *Father Ted* was really quite simple: three Irish Roman Catholic priests and their housekeeper live on a bleak island off the west coast of Ireland in exile after having been banished there by the Church for various misdemeanours in their past. Father Ted's impropriety appears to have been some kind of financial incident, which he frequently defends by saying, 'The money was just resting in my account!' Father Jack has been banished for his alcoholism, womanising and unusual brand of Tourettes Syndrome, and we never get the full story that results in Father Dougal being on the island. All we know is that it was something referred to only as 'The Blackrock Incident' in which hundreds of nuns' lives were irreparably damaged!

The series ran for twenty-five episodes across three series, plus a Christmas Special, between 1995 and 1998, and was quite unlike most of the other sitcoms at the time or that had come before it. This was deliberate and Linehan had previously described the show as being a satire or parody of traditional sitcoms.

In one episode Ted accidentally destroys a car which is the prize for a raffle by trying to fix a small dent in the body. As he taps out the dent he makes it worse and, in trying to fix the bigger dent, he makes that worse too. After hours of 'repairs' the whole car is eventually wrecked! To make sure his boss, Bishop Len Brennan, doesn't find out what has happened to the car, Ted comes up with a plan to borrow a friend's car which happens to look identical. Ted hopes that he will rig the raffle so that Father Dougal wins the car and when the dust has settled they will return their friend's car so that no one is any the wiser. Of course things don't go quite right: a drunken Father Jack steals the borrowed car to get himself some more alcoholic drinks and crashes it into two trucks, and the whole plan is ruined.

Probably the most popular and defining comedy series of the whole of the nineties was, of course, *Friends*, the hit American sitcom starring Jennifer Aniston, Courteney Cox, Lisa Kudrow, Matt LeBlanc, Matthew Perry and David Schwimmer. The show ran for a total of 236 episodes from 1994 until 2004 and followed the lives of struggling actor and sandwich enthusiast Joey Tribbiani, wise-cracking businessman Chandler Bing, dim waitress Rachel Green, quirky songwriter Phoebe Buffay, stuffy palaeontologist Ross Geller and his obsessive-compulsive sister Monica Geller as they live and work in Manhattan, New York.

Over the course of ten seasons, we grew to love this little group of friends and came to see them as an extension of our own social circle. We longed to join them on the famous sofa at Central Perk cafe and be invited to dinner with them in Monica's apartment. Women wanted to date Joey and men wanted to be Joey, and we all desperately wanted our friends Rachel and Ross to get together.

Each episode was filled with twenty-two minutes of laughter and occasionally tears as we watched the six friends navigate their way through life in the big city, growing up, getting married, having children and sharing the most important and intimate details of their lives together, treating each other as though they were all one big, unrealistically happy family.

When *Friends* eventually came to an end in 2004, the final episode brought tears to the eyes of not only the audience but also the cast, who had spent the last ten years working closely together.

For many of us, *Friends* is still the benchmark of TV comedy. It is the standard by which we measure all other comedy programmes, and even today we compare new sitcoms with *Friends*, defining them as either 'not as good as *Friends*' or 'a bit like *Friends*' and very rarely 'better than *Friends*'. The *Friends* theme song, 'I'll Be There For You' by the Rembrandts, means more to us than just a reminder of an old TV show: it has come to represent the best of our nineties childhood. A time of happiness, of good television and good friends. Television will never be quite the same again.

Five

MOVIES

It's not until you look back, from a distance, that you can truly appreciate the way that a movie can both reflect and shape an entire generation. When we watch a new movie for the very first time, we have little awareness of the impact that it's going to have on our future – the way it will shape our fashions and our interests, the way we talk and even the way we behave.

From the close-up perspective, neither can you see that the movie you're watching will one day become a treasured snapshot of a long-lost era, a time capsule of fashions and culture with a remarkable ability to resurrect the memories and feelings associated with that time in our lives.

It's a bit like standing too close to a television screen and seeing the individual pixels flickering in front of you but without being able to discern the overall image. It's not until you step back, with the benefit of a little distance, that the picture comes into focus and you can begin to see how each tiny pixel forms part of a complex tapestry that contributes to the big picture.

It's with the benefit of decades of distance that we can now look back and pick our way through some of the iconic

movies of the nineties, enjoying the memories that they bring us that reflect the very essence of the era and also recognising the powerful influence that these films had on the world and our very own lives.

The first of the big, iconic movies of the nineties was *Pretty Woman*, the romantic comedy with an adult theme, which arrived in cinemas early in 1990 and starred cinematic veteran Richard Gere and relative newcomer Julia Roberts.

The film was loosely based on the classic *Pygmalion/My Fair Lady* concept of taking a working-class girl (in this case, not a working-'class' girl but a 'working girl') and introducing her to high society, and, with a little training, seeing if she can pass herself off as someone more socially refined than she actually is. While there are some fairly dramatic ups and downs in the story and naturally some quite controversial topics, the end result was actually a memorable and enjoyable romantic comedy that was one of the most successful films of the nineties.

This was Julia Roberts's big break-out movie and, prior to this, we'd only ever seen Roberts in the low-profile movie *Mystic Pizza* and a handful of small TV roles including a minor part in *Miami Vice*.

Although many high-profile actresses were approached to play the lead role of Vivian, the call girl from downtown LA, none of them wanted to take the part, perhaps because they didn't want the seedy life of the character to tarnish their own reputation.

The first choice to play Vivian had actually been Karen Allen, the actress who played Marion Ravenwood in *Raiders of the Lost Ark*, but when she turned the role down, the part was offered in turn to Meg Ryan (*You've Got Mail*), Molly Ringwald (*The Breakfast Club*), Mary Steenburgen (*Back to the*

Future III), Diane Lane (*The Perfect Storm*), Michelle Pfeiffer (*Dangerous Minds*), Daryl Hannah (*Splash*) – who felt the movie was degrading to women – Valeria Golino (*Rain Man*) and Jennifer Jason Leigh (*Road to Perdition*). It seems that only Winona Ryder (*Edward Scissorhands*) actually wanted the part but was refused it since she was too young at the time. What had been a casting headache for the producers of the film turned out to be a blessing for Julia Roberts, though; she was catapulted to stardom as a result of the somewhat unexpected success of the movie.

A few months later, also in 1990, an even bigger comedy hit the cinemas with *Home Alone*, starring Macaulay Culkin. It was so successful that it became the third highest-grossing film of all time after *ET: The Extra-Terrestrial* (1982) and *Star Wars* (1977).

The film was written and produced by John Hughes, who was responsible for many legendary comedies of the eighties and nineties, including *Ferris Bueller's Day Off* (1986), *Planes, Trains and Automobiles* (1987), *Christmas Vacation* (1989) and, of course, *Uncle Buck* (1989), which also starred Macaulay Culkin.

The movie tells the story of 8-year-old Kevin McCallister, who is accidentally left at home when his large and chaotic family all head off to Paris for Christmas. While at home on his own, young Kevin gets up to all sorts of mischief and ends up having to defend his home from would-be burglars (Joe Pesci and Daniel Stern) using a series of elaborate makeshift booby traps to keep them away. While the film is clearly a comedy, the slapstick humour in the booby-trap scenes is actually so violent that in real life the burglars would have been killed within minutes. In a kind of 'Tom and Jerry' alternative reality, the repeated dropping of bricks on people's heads only results

in hallucinations of little tweeting birds rather than inducing severe cranial haemorrhaging.

There's also a slightly sinister subplot to *Home Alone* that involves the next-door neighbour 'Old Man' Marley who is rumoured to have murdered his entire family with a snow shovel. Little Kevin is terrified of him, but it turns out that the old man is actually very kind and gentle, except towards the end of the movie when he rescues Kevin from the clutches of the burglars by knocking them unconscious with his snow shovel, thereby somewhat calling his newly assumed innocence into question!

John Candy also makes a brief appearance in the film playing 'Gus Polinski – the Polka King of the Midwest' in a role that was inspired by the character of Del Griffith, the shower-curtain-ring salesman also played by Candy in *Planes, Trains and Automobiles*. Both characters are sad and slightly pathetic men with a false joviality that masks some kind of emotional darkness, but there's a significant difference between the two; while Del Griffith was lonely with no family, Gus Polinski indicates that he does indeed have a family, although he rarely sees them.

In fact, in one scene Kevin's mother Kate McCallister (Catherine O'Hara) is feeling that she's a bad mother for accidentally leaving her son at home and asks Gus if he ever went on vacation and left his child at home. He tells her that he never did that but he did leave one of his kids at a funeral parlour once! He then explains that the child was left there all day with the corpse and that they went back at night to collect him when they realised he was missing. To reassure Kate, though, he points out that the child was OK and that after two or three weeks he came around and started talking again!

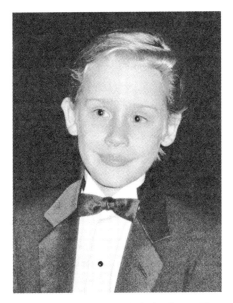

Macaulay Culkin when he still looked really cute. This photo was taken around the same time as *Home Alone* and *Uncle Buck* were filmed.

Macaulay Culkin's younger brother Kieran also appears in *Home Alone*, playing Kevin McCallister's brother Fuller. While Kieran is far less famous than his brother, he has actually had a successful acting career in his own right, appearing in significant roles in numerous Hollywood films, including playing Steve Martin's son in *Father of the Bride* (1991). Macaulay and Kieran also appear together in another John Hughes comedy, *Only the Lonely* (1991), starring John Candy.

The year *Home Alone* was in the cinemas was also the year we saw the release of the bizarre supernatural romance movie

Ghost starring Demi Moore and the late Patrick Swayze, before he died, playing someone who is alive who then dies, and when he's dead thinks he's alive until he discovers he's actually dead but still hangs around with his girlfriend who is alive. Despite the many, many strange scenes in this film, if you ask anyone what they remember most from *Ghost*, chances are the first thing they'll mention is the sexy pottery lesson scene accompanied by the 'Unchained Melody' song.

Shortly after the release of the film, there was a sharp surge in the number of middle-aged women purchasing potter's wheels and clay and, perhaps not coincidentally, there was also a sharp surge in the number of middle-aged couples suffering potter's-wheel-related injuries.

The following year saw Geena Davis and Susan Sarandon playing *Thelma and Louise* (1991) in what was an enormous critical and commercial success that was a deserving recipient of numerous awards. The movie was directed by Ridley Scott who had previously directed *Alien* (1979) and *Blade Runner* (1982) and is generally considered to be the movie that launched the career of the young Brad Pitt, who plays the love interest, JD.

Thelma and Louise are friends who decide to break out of their ordinary lives and take an exciting road trip together in a '66 Thunderbird. Unfortunately, it's not long before the pair run into trouble when a man tries to assault Thelma, and Louise kills him in defence. Fearing that the police won't believe their self-defence claim, they decide to go on the run to Mexico, indulging in increasingly wild behaviour along the way that at one point involves them locking a police officer in the trunk of his car at gunpoint.

In another scene, they teach a trucker a lesson for his misogynistic and male chauvinistic behaviour by forcing him to apologise for his poor manners at gun point, and when he refuses, they shoot and blow up his petrol tanker truck, leaving him stranded in the desert.

The movie has a strong feminist theme and indulges a fantasy of women taking the upper hand over men empowered by their own inner strength, intelligence, sexuality and the use of firearms if the other qualities don't work. Of course, the feminist movement doesn't generally espouse the use of guns to achieve equality with men and so the consequence of this unorthodox feminist adventure is that the pair are hunted down by the police and eventually cornered at the edge of the Grand Canyon with the police behind them and a sheer drop before them. They face certain imprisonment for their behaviour and so Thelma suggests that they 'keep going', to which Louise agrees and the movie ends with them driving the car over the edge of the cliff together. Powerful stuff.

A few months after Thelma and Louise's rendezvous with eternity at the bottom of the Grand Canyon, something a little lighter hit the cinemas in the shape of *Father of the Bride* (1991), starring Steve Martin and Diane Keaton. This light-hearted family comedy tells the tale of middle-aged business owner George Banks coming to terms with his daughter growing up, getting married and leaving home. While Steve Martin got most of the funny lines in the script, for obvious reasons, the real comedic star is Martin Short who plays Franck (Fronk) Eggelhoffer, the camp-as-you-like wedding planner with a peculiar pseudo-European accent that George Banks (Bonks) finds impossible to interpret.

The commercial success of *Father of the Bride* led to the production of a sequel in 1995 simply called *Father of the Bride Part II*, where George has to come to terms with both his wife and daughter being pregnant at the same time. Again Franck brings the comedy in his role as organiser of the baby shower.

Also in 1991 we saw the arrival in cinemas of the classic American comedy *City Slickers*, starring Billy Crystal, Daniel Stern (one of the 'Wet Bandits' from *Home Alone*), Bruno Kirby and Jack Palance. In this light-hearted movie, a group of three friends decide to escape the various challenges of their home lives by taking a two-week horseback cattle drive from New Mexico to Colorado. Having no experience of riding or life in the desert, they are accompanied by tough old cowboy Curly, played by Palance, who leads them in their adventure. Unfortunately, Curly dies of a heart attack during the journey leaving the inexperienced trio to continue the drive on their own, learning some important life lessons as they go.

At one point during casting, the role of Curly was offered to Hollywood acting veteran Charles Bronson (*The Great Escape*), who allegedly turned the role down in a somewhat rude manner when he found out that his character died. Jack Palance, however, accepted the role gratefully and ended up winning an Oscar for 'Best Actor in a Supporting Role' at the 1992 Academy Awards.

In 1994 a sequel called *City Slickers II: The Legend of Curly's Gold* was released, although the only awards this film got close to were its nominations for 'Worst Remake or Sequel' at the Razzie Awards and 'Worst Sequel' at the Stinkers Bad Movie Awards!

This wasn't the only dubious comedy movie of 1994, though, since, just two months earlier, the famous or perhaps

notorious *Dumb and Dumber* arrived in cinemas, starring the rubber-faced and clown-like Jim Carrey alongside the much more subdued but moderately funny Jeff Daniels. The movie tells the story of two dim-witted but lovable brothers, Harry and Lloyd, who travel across the country to return a brief-case full of cash to its rightful owner while being pursued by hired killers and the police. The tagline for the movie was 'For Harry and Lloyd, every day is a no-brainer!' And to be honest you really did need to disengage your own brain somewhat to fully appreciate the non-stop silliness and slapstick humour throughout the film.

For Jim Carrey, *Dumb and Dumber* was just one of the three major movies he starred in that year, making 1994 his break-out year. As well as playing Lloyd Christmas in *Dumb and Dumber*, he also played the lead role in the fantasy comedy *The Mask* and the character of Ace Ventura in *Ace Ventura: Pet Detective*, each of which made the most of his talents as an inveterate clown, and so it came as something of a surprise when he broke the mould in 1998 with a semi-serious role in *The Truman Show*.

Lead character Truman Burbank, played by Carrey, was the star of a reality TV show which had been secretly filming him for his entire life, since birth. Poor Truman had no idea that his entire life was actually a television show and that all his friends were actors until one day he discovered the truth. This was not like any of Carrey's other movies up to that point and for the first time we saw him playing an emotional and intense role with real passion in a way that didn't require him to make any funny faces or do silly voices. The result of his outstanding performance was that he won a Golden Globe for 'Best Performance by an Actor in a Motion Picture' in 1999.

Back in 1993, before Jim Carrey had even been heard of by most people, the much-loved US comedy actor Bill Murray was starring in yet another classic comedy, *Groundhog Day*, having already entertained us with numerous fantastic movies such as *Caddyshack* (1980), *Stripes* (1981), *Ghostbusters* (1984), *Scrooged* (1988) and *What About Bob?* (1991), among others.

Groundhog Day is set in the small Pennsylvania town of Punxsutawney where, every year on 2 February, a traditional ceremony takes place where a groundhog called Punxsutawney Phil emerges from his temporary home on Gobbler's Knob a couple of miles from the town. The tradition says that if Phil sees his shadow and returns to his hole then there will be a further six weeks of wintery weather to come, whereas if he does not see his shadow there will be an early spring.

In the film, Bill Murray places the irascible TV weatherman Phil Connors who, much to his disgust, is sent to Punxsutawney to broadcast live footage of the Groundhog ceremony. For a reason that is never actually explained, every morning Phil Connors wakes up to the same song on the radio ('I Got You Babe' by Sonny and Cher) and the radio presenter saying 'OK, campers, rise and shine and don't forget your booties because it's cold out there today ...', indicating that he is reliving the same day over and over again. Every day is 2 February and Phil sees the same people, watches the same things happen and is eventually able to predict everything that is about to take place since he has seen it all before.

While Phil initially takes advantage of this unusual opportunity to eat as much junk food as he wants without putting on weight, be rude to people with impunity and even rob a security truck without getting caught, he soon tires of his self-obsessed lifestyle and attempts to become a better person

by treating people with love and respect, learning to play the piano like a virtuoso and repeatedly trying to save the life of a homeless man.

Eventually he falls in love with co-worker Rita, played by Andie MacDowell, and works tirelessly to impress her and get her to fall in love with him in the space of just one day before everything is reset and he starts the day over again. It's only when he finally succeeds in this mission that he escapes the eternal repetition of Groundhog Day. The movie is littered with great one-liners delivered in Bill Murray's trademark deadpan style, such as when Rita asks Phil, 'Do you ever have déjà vu?' to which Phil replies, 'Didn't you just ask me that?' And the classic, 'What if there is no tomorrow? There wasn't one today.'

Apparently, during filming, poor Bill Murray was actually bitten twice by the lovable-looking but seemingly ferocious Punxsutawney Phil and required a rabies shot as a result. Director Harold Ramis commented on this incident, saying, 'To be bitten twice means [Murray] stuck around after being bitten once. He's very game!'

The same year that *Groundhog Day* was released, another equally iconic comedy, *Mrs Doubtfire*, premiered, with the starring role taken by Robin Williams who was already well known to us for his appearances in films such as *Cadillac Man* (1990), *Dead Poet's Society* (1989) and *Good Morning Vietnam* (1987), among others.

While on one level *Mrs Doubtfire* is a heartwarming comedy about an estranged father desperately trying to make contact with his beloved children, on another level it is a downright creepy portrayal of an emotionally unbalanced man who adopts prosthetic disguises and dresses as a middle-aged

woman in order to sneak his way back inside the family home. Of course, the film is best enjoyed if you watch it like a 10-year-old, taking it at face value and suspending your cynicism regarding Williams's character's disturbing behaviour. One of the most memorable scenes takes place in the family kitchen when Mrs Doubtfire accidentally sets fire to her (his?) fake bosom while leaning over the stove and tries to put the flames out with a pair of saucepan lids, leaving a large pair of burn marks on his (her?) chest.

Robin Williams's portrayal of Mrs Doubtfire is considered by many to be one of his most impressive achievements in a varied acting career. A large part of the dialogue and even

Andie MacDowell holding a groundhog. I'm guessing this photo has more to do with her role in *Groundhog Day* than the part she played in *Four Weddings and a Funeral*.

some of the scenes in the film were completely improvised by Williams, who was given free rein by director Chris Columbus to do whatever he wanted. As a result, all of Williams's scenes were filmed with two cameras since no one knew quite what he was going to do next. The scene where Mrs Doubtfire's false teeth fall out into the wine glass in the restaurant, for example, was completely improvised and the looks of shock and disgust on the other actors' faces is genuine!

Throughout the nineties, Hollywood churned out hundreds of comedy movies with something to suit virtually everyone's taste, from gentle romantic comedies like *Sleepless in Seattle* (1993) and *You've Got Mail* (1998) to the wild and irreverent *Wayne's World* (1992) to high-school comedies such as *Clueless* (1995) and gag-filled spoofs like *Austin Powers: International Man of Mystery* (1997) and, of course, the *Naked Gun* series, which had begun in 1988 and continued in 1991 with *The Naked Gun 2½: The Smell of Fear* and completed its trilogy in 1993 with *Naked Gun 33⅓: The Final Insult*.

As well as all the American comedy, our own British film industry contributed a number of outstanding comedy films in the decade, each with that unique and quirky humour that characterises British comedy.

The laughs began in 1990 with Eric Idle and Robbie Coltrane dressing up and pretending to be nuns in the somewhat underrated crime caper *Nuns on the Run*, and continued in 1992 with the end of a thirty-four-year-long era with *Carry On Columbus*, the last ever (and worst ever) *Carry On* film.

In 1994, the very British and very smug Hugh Grant smarmily charmed us in his lead role as Charles in the hugely successful *Four Weddings and a Funeral*, alongside co-stars James Fleet, Simon Callow, John Hannah, Kristin Scott Thomas and

Andie MacDowell, the token American in an otherwise all-British cast.

The following year a slightly less smug but equally British Grant starred in the quaint and parochial film *The Englishman Who Went Up a Hill But Came Down a Mountain*, which was so British it was like having a nice cup of tea and a digestive biscuit inside a red phone box while singing 'God Save the Queen'. Grant played Reginald Anson, the unfortunate English cartographer who has to break the bad news to a small Welsh village that their mountain is actually only a hill and not technically a mountain after all since it falls slightly short of the 1,000-foot height requirement for a mountain. The local community are so upset that they rally together to build a sort of earthen cairn on top of the hill to raise its height to just over the limit to assure its status as a true mountain.

Only the British film industry could take a gentle story like this and turn it into a worldwide box office success. If Hollywood had tried to make this film, it would have inevitably involved a car chase and a few explosions here and there, but the very subtlety of this film is what gives it its charm.

In 1996 the slightly grittier comedy *Brassed Off* hit the cinemas, starring Pete Postlethwaite and a young Ewan McGregor. While the film was essentially a romantic comedy with a 'Romeo and Juliet'-style forbidden romance within a colliery brass band, it was set against the somewhat unusual backdrop of a deprived mining town in the north of England which had seen the closure of its pits and the consequential loss of employment and the decline of its community.

And in 1997 a very similar gritty backdrop was used for the popular comedy *The Full Monty*, where poverty and redundancy resulted from the closure of the Sheffield steel mills.

This time, instead of taking refuge in a brass band, the main protagonists decide to form their own male striptease act in an attempt to earn some money for themselves. The surprising critical success of the film resulted in it winning the BAFTA Award for 'Best Film' in 1998, beating off front-runners *Titanic* and *L.A. Confidential*. Robert Carlyle also won the BAFTA for 'Best Actor in a Leading Role'.

And then in 1999 Hugh Grant was back with another romantic comedy, *Notting Hill*, starring alongside Julia Roberts in the tale of a humble bookshop owner who happens to fall in love with the most famous film star in the world.

As well as quaint and quirky comedies starring smug and smarmy Englishmen, the British film industry was also responsible for something a whole lot more sophisticated: Bond. James Bond. The first of the nineties James Bond films came in 1995 after a six-year hiatus in filming and introduced the world to a brand new Bond actor, Pierce Brosnan. The arrival of the charming, suave, well-groomed and consummate Englishman was a welcome move for many Bond fans who had not been enamoured with Timothy Dalton, who had most recently played Bond in *Licence to Kill* (1989).

The first of the Brosnan-era Bond films was the long-awaited *GoldenEye* in 1995, which featured Bond-baddies taking control of the dangerous GoldenEye satellite weapons that could wreak havoc with powerful electromagnetic pulses. With the help of Bond-girl Isabella Scorupco playing Russian scientist Natalya Simonova, Bond faces bad guys Sean Bean as good-agent-gone-bad Alec Trevelyan and the unlikely bad guy Alan Cumming as Russian scientist Boris Grishenko.

GoldenEye was so successful that it almost doubled the box office sales of the previous films and led to the near-immediate

production of the next Bond movie, *Tomorrow Never Dies*, which was released in 1997. This time, Brosnan faces Bond-baddie Elliot Carver (played by Jonathan Pryce), who is a media mogul trying to incite war between China and the UK in order to obtain exclusive media coverage of the ensuing conflict. With the help of Chinese agent Wai Lin, played by Michelle Yeoh, the pair defeat the evil plans and sink Carver's 'stealth' ship before it can fire a British cruise missile at Beijing.

And then in 1999 we saw the final Bond film of the decade with *The World Is Not Enough*, which saw Bond face the truly terrifying bad guy Renard, played by Robert Carlyle. The somewhat convoluted plot had something to do with pro-tecting the daughter of an oil tycoon, Elektra King (played by Sophie Marceau), who turns out to be a baddie herself, and then averting a nuclear catastrophe when Bond has to disarm a bomb on a submarine. He is helped this time by American nuclear physicist Christmas Jones, played by Denise Richards, who dressed very much like Lara Croft in *Tomb Raider*.

The nineties was also the decade in which computer-generated imagery (CGI) special effects came of age in the movie industry, having reached a point of sufficient realism and affordability that hadn't been previously achieved in the seven-ties and eighties. For the first time, special effects in movies began to replace the traditional models, puppets and 'invisible' wires that had been used for many years with the new digital effects that were far superior and more realistic than anything the world had ever seen before.

One of the most striking examples of early movie CGI can be seen in *Jurassic Park* (1993), which marked a turning point in movie history through its extensive use of digital dinosaurs

that were so realistic you could be forgiven for thinking they truly existed.

The dinosaurs were created with groundbreaking new CGI techniques from special-effects production company Industrial Light and Magic, combined with footage of life-sized animatronic dinosaurs in some scenes. The end result was so spectacular that *Jurassic Park* became the highest-grossing film ever made at that time.

Prior to the arrival of *Jurassic Park* there had been many dinosaur movies, of course, but they had all relied on traditional special effects, such as the stop-motion animation used in the classic 1954 original *Godzilla* movie. Pioneering special-effects legend Ray Harryhausen had, for many years, pushed the boundaries of what was achievable with animated models and brought us fantastic mythical creatures and armies of fighting skeletons through his 'Dynamotion' animation technique. But while the art form was admirable and even beautiful in its own way, there was no denying that it really wasn't very realistic.

The dinosaurs in *Jurassic Park*, though, were so realistic that you really couldn't quite believe what you were seeing and only your knowledge that dinosaurs were extinct kept you from believing that they were the real deal. These digital dinosaurs were far more than just an impressive visual effect, since they represented an exciting new era in modern cinema where film-makers would not only be able to create more realistic, immersive and powerful movies than ever before, but would be able to explore themes and ideas for movies that would have previously been either impossible or unfeasible to produce, such as *The Matrix* (1999) for example.

Starring Keanu Reeves and Laurence Fishburn, *The Matrix* depicts a dystopian future in which the reality experienced by most humans is actually a dream-like simulated digital reality. While the storyline, soundtrack and acting all deserve special mentions in their own right, the element of particular interest here is the stunning special effects that made the film possible.

The success of *Jurassic Park* and other CGI-led movies such as *Independence Day* (1996), *Twister* (1996) and *Men in Black* (1997) had resulted in the development of even more advanced CGI special effects and the technology was becoming more and more sophisticated every day. By 1999, directors the Wachowski Brothers and producer Joel Silver were able to leverage existing technology to develop their very own special effect called 'Bullet-Time', which is used in one of the most famous sequences in the *The Matrix*. The entire scene shifts into slow motion while the camera whizzes around Keanu Reeves in normal time as he dodges bullets flying towards him.

At the time, the technique was so revolutionary that it stunned everyone who saw it and was so complicated to produce that it required dozens of special cameras, green screens and other equipment, a large team of people to operate it all plus vast amounts of custom computer programming and rendering at eye-watering costs. In a reflection of the way computer technology keeps progressing, around fifteen years later that very same special effect had become so commonplace and affordable that it was being used in low-budget TV advertising. I'm sure it's only a matter of time before it becomes a built-in filter on our smartphones.

Disaster movie *Twister*, starring Helen Hunt and Bill Paxton, also made use of new CGI effects to wow the audience with close-up shots of powerful tornadoes and waterspouts with a

very memorable scene of a flying cow being hurled through the air by the raging storm. And, of course, *Men in Black* used CGI to create super-realistic looking aliens but, for me, the best use of all was when the theme song from *Men in Black* was released as a single and the music video featured Will Smith dancing in sync with a green alien!

At the same time that CGI was being used to create dazzling special effects for action movies, an American company called Pixar decided to use the technology to create the world's first fully computer-animated feature film: *Toy Story* (1995). Again,

Leslie Nielsen, the comedy actor who played Lt Frank Drebin in the *Naked Gun* films.

we didn't realise at the time quite how significant this film was. Not only has *Toy Story* been consistently voted as the best animated film of all time, winning numerous accolades and awards, but it heralded the introduction of an entirely new genre of movie which simply never existed before. Before the decade was out, Pixar would release two more fully computer-animated films with *A Bug's Life* in 1998 and the much anticipated *Toy Story 2* in 1999.

DreamWorks Pictures decided to join the genre with its own fully computer-animated film *Antz*, which was released at virtually the same time as Pixar's *A Bug's Life* in a blatantly competitive move. Both films had an ant as the main character and the two films went head to head at the cinemas in October and November 1998. *A Bug's Life* won the box office battle, taking nearly twice as much revenue as *Antz*, but DreamWorks were not put off and went on to create dozens of successful animated films including *Shrek* (2001), *Madagascar* (2005) and *Kung Fu Panda* (2008).

Quite apart from the introduction of computer-animated movies and the awesome advances in CGI technology, the nineties represented an important era in the history of cinema, with the production of dozens of critically acclaimed films that have completely changed the face of the movie industry.

Starting in 1990, the three-hour-long epic *Dances with Wolves*, starring and directed by Kevin Costner, redefined the modern western movie genre and went on to win seven Oscars and three Golden Globe awards, among numerous other accolades. One of the Oscars was for 'Best Music, Original Score' for the powerful and dramatic soundtrack written by John Barry, the man behind the James Bond music.

Also in 1990 came the quirky fantasy story *Edward Scissorhands*, starring Johnny Depp and directed by Tim Burton. As well as pushing the boundaries of surreal gothic fantasy, *Edward Scissorhands* led to a long-term partnership between Depp and Burton which would ultimately result in their collaboration on movies including *Ed Wood* (1994), *Sleepy Hollow* (1999), *Charlie and the Chocolate Factory* (2005), *The Corpse Bride* (2005) and *Sweeney Todd: The Demon Barber of Fleet Street* (2007).

1991 saw the release of *Terminator 2: Judgement Day*, in which Arnie (Arnold Schwarzenegger) reprised his role as the Terminator, a cyborg sent from the future to protect Sarah Connor's 10-year-old son from another, more advanced cyborg. The stunning special effects in this film were ground-breaking at the time, especially the liquid metal effects used for the T-1000 cyborg who morphs into human form from a pool of molten metal. Nothing quite like this had ever been seen before, and the effects were an inspiration to countless movies and even music videos that followed.

New boundaries for the horror/thriller genre were also set in 1991 with the release of the – much parodied – *Silence of the Lambs*, starring Jodie Foster and Anthony Hopkins. Quentin Tarantino began his spree of ultra-violent crime thrillers in 1992 with *Reservoir Dogs*, which was followed in 1994 with what is considered to be his masterpiece, *Pulp Fiction*.

Forrest Gump stole the show in 1994, though, with Tom Hanks starring in the comedy-drama that told the tale of a mentally challenged man's bizarre journey through life which resulted in him inadvertently playing a role in some of the most defining moments in history. The famous scene with Tom Hanks sitting on a bench telling strangers in an Alabaman

drawl 'Life is like a box of chocolates ...' has become one of the most iconic scenes in movie history.

While *Forrest Gump* became the second highest-grossing film of 1994, after Disney's *The Lion King*, the most compelling film of the year was undoubtedly *The Shawshank Redemption*, which is universally accepted as one of the greatest films of all time. In fact, for a while it topped the list of all films on the Internet Movie Database (IMDB) as the number one film with the highest ratings, and it currently has a score of 9.3 out of 10 as voted for by nearly 2 million people. The film starred Tim Robbins and Morgan Freeman as two men in prison, one of whom is innocent, and follows the story of a man trying to come to terms with his new life in incarceration and his eventual redemption.

1995 saw the release of *Apollo 13* ('Houston, we have a problem ...') and *Jumanji*, the family fantasy adventure with Robin Williams, while 1996 brought us *Trainspotting, Jerry Maguire* and *The Nutty Professor* with the awesome Eddie Murphy playing Professor Sherman Klump.

By far the most commercially successful film of 1997 was *Titanic*, which featured Leonardo DiCaprio and Kate Winslet taking the roles of Jack Dawson and Rose Bukater. The account of the maiden voyage of the *Titanic* was historically accurate in many places, although a fictional love story between Jack and Rose was layered on to the actual events of the disaster to add a whole other dimension.

At the time, the film was the most expensive ever made with a budget of around $200 million, which had to cover the cost of building replica interiors as resplendent as those on the *Titanic* itself and recreating large sections of the ship's exterior, some of which can still be seen when driving down the coast road near Rosarito Beach in Mexico.

Despite the enormous production cost, the movie was a commercial success, taking an estimated $2 billion at the box office and becoming the highest-grossing film of all time until 2010 when the movie *Avatar* broke a new record. *Titanic* was also a critical success, earning eleven Oscars at the Academy Awards and three Golden Globes. The success of the film also resulted in the theme song, 'My Heart Will Go On' sung by Celine Dion, becoming one of the biggest-selling singles of all time.

In 1998, the disaster movie *Armageddon*, starring Bruce Willis, was the most commercially successful film of the year, narrowly beating Steven Spielberg's masterpiece Second World War epic drama, *Saving Private Ryan*, which starred Tom Hanks. The film tells the story of a group of American soldiers who go behind enemy lines in occupied France after the D-Day invasion and attempt to rescue a paratrooper whose brothers have all been killed in the war.

The opening battle scene is one of the most dramatic and realistic portrayals of the D-Day landings ever made and, when it was shown on a large cinema screen with immersive surround sound, the audience literally jumped and flinched as the bullets seemed to whizz over their heads. While the film was not an easy watch at times due to the realistic and violent nature of the battle scenes, it was so powerfully moving that audiences exiting the cinema came out in stunned silence, feeling like they themselves had just spent the last three hours on the battlefield.

In the final year of the decade, *Star Wars Episode I: The Phantom Menace* was the most commercially successful film, followed by supernatural horror *The Sixth Sense* and then *Toy Story 2*, with *The Matrix* in fourth position. 1999 also

saw the introduction of a new genre of horror film with the shaky hand-held camera movie *The Blair Witch Project* and also birthed another of the most critically acclaimed films of the decade, *Fight Club*, starring Brad Pitt and Edward Norton.

As we came to the end of the nineties, we not only concluded the most outstanding decade in cinematic history but we also reached the end of an entire century of film. Ninety-nine years earlier, in 1900, motion pictures were black and white and completely silent, with low-quality props and scenery and poor special effects, and they could only be watched at a cinema. But by the end of the century we had full-colour, surround-sound, big-budget movies with ultra-realistic special effects and CGI along with 3D glasses and IMAX screens, and we could watch them at the cinema or at home on our DVD players and home cinema systems.

Looking back at the history of cinema, its clear that the nineties was one of the most significant decades of all time. The advances in special effects and CGI rival the introduction of sound and colour in importance, and the quality and production values of films reached an all time high. While, at the time, we had no concept of what was to come, we can see with hindsight that the nineties laid the foundation for the advances that have led to the films we watch today. The nineties formed a perfect bridge between the low-tech cinema of the twentieth century and the high-tech cinema of the twenty-first.

But while the eye-popping visuals of today's cinema satisfy a desire for the most realistic cinematic experience known to man, there's something very special about sitting down to watch an old nineties movie, laughing at the way we used to dress, singing along to the music we used to listen to and enjoying a brief visit to the decade that made you who you are.

Six

TOYS AND GAMES

We were right there at the turning point in history when children transitioned from spending the majority of their time playing with traditional toys and games, many of which would have been familiar to children from the sixties, seventies and eighties, to spending the majority of their time immersed in the all-consuming new world of smartphones and social media.

The transition towards an electronic childhood had begun in the 1970s when arcade games and games consoles first arrived on the scene, offering children and adults alike the opportunity to play low-fi classics such as *Pong* and *Space Invaders*. By the eighties, computer gaming had become a mainstream pastime for many children, and advances in technology saw the arrival of an increasing number of electronic hand-held games, such as the Nintendo Game and Watch with popular titles like *Donkey Kong* and *Mario Bros*.

By the nineties, computer gaming had matured somewhat and we witnessed the introduction of increasingly advanced and more realistic games consoles throughout the decade. First up was the hand-held Nintendo Game Boy, which made its debut in Europe in 1990 and became an almost overnight

success. The Game Boy featured a tiny 160 × 144 pixel display with a 4MHz processor and 8kB of RAM, but this was more than adequate to play the highly addictive game *Tetris* which came bundled with the unit and contributed significantly to its success. The black and white unlit screen combined with the low-processing power and bulky size resulted in amazing battery life, with four AA batteries providing up to thirty hours of non-stop entertainment.

The Game Boy's home console counterpart was the recently released Super Nintendo Entertainment System or SNES for short, which was a 16-bit machine with advanced graphics and sound in comparison to the other consoles of the time.

Just months after the arrival of the Nintendo Game Boy, competitor Atari released their Lynx console, which was the world's first hand-held electronic game with a colour LCD display. Unfortunately for Atari, the short battery life, high price and limited number of games available resulted in poor sales and it was considered a commercial failure.

In 1991 we saw the arrival of the Sega Game Gear which became the Game Boy's most significant rival. Its full-colour, backlit screen and advanced processing power gave it a significant edge over the Game Boy in terms of gaming performance, but its bulky size, three- to five-hour battery life and poor games library resulted in poor sales in comparison. While the Game Gear saw respectable sales of around 10 million units, the Game Boy sold well over 110 million units during the course of its lifetime, making it the second-best-selling hand-held console of all time after the Nintendo DS.

The next major console to be released in the UK was the Amiga CD32 which was the first ever 32-bit home video console and featured an advanced CD-ROM drive and powerful

graphics processing to provide the next generation of gaming. Despite the machine's evident prowess, it only had a limited sales run after manufacturers, Commodore, went bankrupt just months after its release. Despite these troubles, the CD32 sold enough units to account for nearly half of all CD-ROM drive sales in the UK at the time.

Aware of Sony's imminent plans to launch their PlayStation console, Sega released the 32-bit Sega Saturn in 1995 which was the successor to the highly successful Sega Genesis, a 16-bit machine that debuted in 1989 and introduced us to *Sonic the Hedgehog*. The Sega Saturn featured dual processors, a CD-ROM drive and advanced video capabilities, but was no match for the PlayStation whose super-advanced capabilities and excellent games library led to sales of around 100 million units.

Both the Sega Saturn and the PlayStation were the first consoles to introduce us to the legendary *Tomb Raider* games,

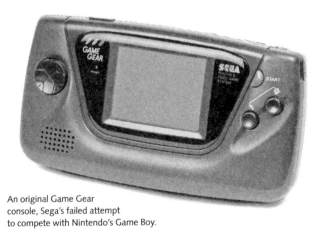

An original Game Gear console, Sega's failed attempt to compete with Nintendo's Game Boy.

which featured the pony-tailed, short-shorts-wearing and ample-bosomed Lara Croft, the gun-toting heroine. The first-person shooter-style game was advanced for the time and its use of a female protagonist polarised opinion as to whether this constituted a positive or negative feminist message.

The relentless march of progress resulted in the launch of the Nintendo N64 in 1996, with a powerful 64-bit architecture, and in 1999 Sega upped the ante yet again with the awesome Dreamcast console, which was the most powerful games console on the market at the time. The Dreamcast was well ahead of its time in many ways, with a built-in modem for Internet support and online gaming, and it rivalled the forthcoming PlayStation 2 in terms of its technical capabilities. But the unit was not a commercial success and Sega reluctantly withdrew the product from market, exiting the home console market for good.

In addition to games consoles, many people had home computers in the nineties, and games were often produced for the Amiga 500, Atari ST and PC platforms simultaneously. In 1991, one of the strangest and yet most successful gaming concepts of all time arrived for home computers in the form of a game called *Lemmings*.

The aim of the game was to guide a group of pixellated, green-haired lemmings through an increasingly difficult terrain full of obstacles to a safe exit. Unfortunately the seemingly suicidal lemmings would happily follow each other to certain death in pools of lava or off the edge of cliffs unless you equipped them with parachutes or diverted them using blocker lemmings. Bomber lemmings could also be used by setting a five-second timer, after which the dispensable lemming exploded, blasting a crater and clearing any obstacle in

the vicinity. The simplicity of the concept and the humorous gameplay kept us entertained for hours and resulted in *Lemmings* becoming one of the most successful computer games of all time, selling an estimated 20 million copies to date.

Having explained that we were the last generation that played with traditional children's toys rather than becoming immersed in smartphones and social media, I have now made it sound as though all we did was play computer games all day – but the truth is that we actually spent the majority of our time playing with the very same toys that the children of the eighties and even the seventies played with. Most children's toy collections comprised an eclectic mix of hand-me-downs from older siblings and neighbours, along with an assortment of bargains collected from the jumble sale or school fête. These toys were classics like yo-yos, toy cars, Action Man and Barbie dolls, toy guns and teddy bears, and were enjoyed by previous generations just as much as by us.

We too played KerPlunk and Operation and Connect Four, and we too made faces with Mr Potato Head and knocked over rows of dominos and built Lego houses. Like the generations before us we also tried to solve the Rubik's Cube and failed, ending up trying to peel off the stickers and rearrange them to make it look like we had completed it.

But as well as all the old classics, there were plenty of new toys and games that arrived in the nineties which gradually made their way into our toy collections.

In the early nineties, we had the Teenage Mutant Ninja Turtle toy characters from the TV series of the same name. When they first arrived in the UK their name was changed to Teenage Mutant Hero Turtles, which apparently sounded less

violent and, in fact, UK censorship was such that their weaponry was also removed and Michelangelo's nunchaku were replaced with a grappling hook called the Turtle Line. We had toys of the main characters, Donatello, Raphael, Michelangelo and Leonardo, but there were also toys of bad guys Bebop and Rocksteady along with a cool turtle blimp and the turtles' main form of transport, the 'Party Wagon' – a kind of green, armoured ice-cream van with machine guns on the roof and no ice cream inside.

We also played with Mighty Morphin Power Ranger toys, which featured the brightly coloured superheroes dressed in spandex suits and visors ready to athletically battle their giant enemies with their Blade Blaster guns. We also had James Bond action figures, Batman, Spiderman, Hulk, and all sorts of other superheroes, along with the tiny Monster in my Pocket characters which were the boys' equivalent of Polly Pocket dolls.

The Monster in my Pocket characters comprised a vast collection of every kind of evil monster, demon and ghoul miniaturised to a convenient pocket size, and were targeted mainly at little boys who were made of 'snips and snails and puppy dog tails' according to the old nursery rhyme. On the other hand, the little girls who were made of 'sugar and spice and all things nice' preferred to play with the far more genteel and delicate Polly Pocket dolls, which were delightful and innocent little characters whose biographies described them as confident, loyal, cool and friendly with an interest in shopping, water-skiing and roller-skating.

The tiny, 1-inch tall figures were apparently invented by a Chris Wiggs in 1983 for his daughter Joanna by using a ladies' powder compact to create a little house for the characters. Wiggs licensed the idea to Bluebird Toys who began mass

producing Polly Pocket in 1989, and the miniature characters with their numerous accessories and cases, which opened out into different themed scenes, became enormously popular.

The original Polly Pockets were quite different from the later dolls and started off life a similar size to Lego characters with a similar single-jointed middle that allowed you to move them into a sitting position. In fact, they were so small that you could stuff your entire collection into a bumbag quite comfortably and take them with you wherever you went, equipped and ready to play at a moment's notice, but also looking super-cool at the same time with your fashionable-at-the-time bum bag around your waist.

The newer Polly Pockets that launched in 1999 were much larger, at around 3¾ inches tall, and featured removable rubbery costumes. The increased size gave Polly Pocket and her friends a distinct advantage when your brother's Monsters in my Pocket army launched a surprise attack on your Polly Pocket tea party, but the downside was that the larger characters no longer fit so neatly in a nineties bumbag.

For the sort of little boy who liked invading his sister's tea parties, one of the most exciting toys of the nineties was the new Nerf Blaster gun. We'd always had toy guns, some with exploding caps to make a 'realistic' gunfire sound, and we'd even enjoyed shooting each other in the head with spud guns loaded with little pellets of raw potato, but the new Nerf Blasters were something else altogether. They were brightly coloured, mean-looking, super-powerful guns that fired foam darts an astonishing distance and at great speed. At the same time the Nerf Super Soaker arrived, which revolutionised the humble water pistol and utilised a pressurised reservoir that could be pumped up by hand to create powerful jets of water

capable of soaking your little sister from over 15 metres away, enabling you to evade both detection and retaliation.

In 1996 a quite different kind of toy arrived: Hasbro's Bop It was a game that simultaneously entertained children and irritated parents with a barrage of noise. The hand-held game essentially comprised a loudspeaker that gave verbal instructions of what to do and a button, a handle and a lever. The game would shout out one of the three commands 'Bop it!', 'Twist it!', or 'Pull it!' and the player would have to quickly bop, pull or twist the appropriate button or lever in the order commanded. As the game progressed the instructions were given faster and faster, with the player scoring points for each correct response. The success of the original game led to a series of variations being produced, with the Bop It Extreme next out of the factory with its additional 'Flick it!' and 'Spin it!' commands and buttons.

While toys like Bop It were extremely popular and sold in large quantities, especially at Christmas, sometimes a toy or game would inexplicably 'go viral' – a phrase that didn't exist in the nineties – and take the world by storm. Throughout the decades, children have succumbed to these occasional crazes or fads that usually begin in a playground somewhere and, somewhat like contagious diseases, spread rapidly from person to person until every child in the nation or even the world is caught up in a fevered state of delirium over some seemingly trivial toy or game which they simply must have. Usually these crazes seem to spring up almost overnight, lasting for a few months or years before suddenly and mysteriously disappearing as though they had never existed. Such was the case with Pogs in the nineties.

It seems that the playground game of Pogs actually dates back as far as the 1920s to the Hawaiian island of Maui, where

bottles of a drink with the brand name 'POG', made from Passionfruit, Orange and Guava (POG – get it?), became the source of the bottle caps that could be used for playing the game originally known as 'milk caps'.

The outbreak of this pandemic craze has been traced back to its probable source in an elementary school in Hawaii, where the old-fashioned pastime was resurrected in 1991 by a teacher who wanted to introduce her pupils to a childhood favourite game of hers. While no one fully understands what causes the outbreak of a craze, it's clear that the game suddenly became massively popular on the Hawaiian island of Oahu before spreading rapidly to the other populated islands nearby, reaching west-coast USA shortly afterwards. The craze swept virulently across America at enormous speed and was then picked up in Europe and the rest of the world.

The simplicity of the game no doubt contributed to its success, with the concept being to simply stack the Pogs face down in piles and then throw a 'slammer', which is a thicker and heavier piece, at the pile to see if you could flip any of the Pogs face up. Each player would then keep any Pogs that landed face up, restock the pile and then the next player would take their turn.

Since Pogs featured thousands of different designs on a variety of themes, they quickly became collectors' items and were traded in playgrounds across the world. Competing brands surfaced calling themselves SkyCaps and Hero Caps, and shortly afterwards a whole new game using a similar form of circular discs called Tazos emerged.

As is the way with many childhood crazes, Pogs were ultimately banned from a number of schools because of the distraction and arguments they seemed to cause among pupils

Buzz Lightyear, the most popular children's toy for Christmas 1996 following the success of *Toy Story* the film.

and the vague suggestion that winning Pogs in a game was essentially a form of gambling, which was not appropriate in a school environment. While the school bans had little effect on the popularity of Pogs, the craze peaked in the mid-nineties with Pogs becoming the best-selling toy of Christmas 1995, and then burned itself out, disappearing as rapidly as it had arrived, leaving retailers with vast stocks of unwanted Pogs.

A significantly longer-lasting childhood collectible arrived in 1993, though, when the very first Ty Warner Beanie Babies

made their way on to retailer's shelves. The cutesy stuffed animals were filled with plastic pellets (or 'beans' – hence the name) and were deliberately under-stuffed, giving them a pliable, bean bag feel that meant the Beanie Babies could be sat on window sills and shelves, moulding themselves to whatever shape was necessary to secure their pose.

Originally a line of nine different characters were available, comprising Brownie the Bear, Spot the Dog, Flash the Dolphin, Legs the Frog, Pinchers the Lobster, Chocolate the Moose, Squealer the Pig, Patti the Platypus and Splash the Whale. Each Beanie Baby had a TY label attached as a mark of its authenticity and collectors were encouraged to keep the tag attached since removal could result in halving the value of the toy.

Forward-thinking entrepreneur Ty Warner, the man behind the Beanie Babies, carefully marketed the stuffed toys to create a strong sense of anticipation, rarity and value by initially only stocking the Beanie Babies in smaller toy shops and gift shops, keeping advertisement for the toys to a minimum and then cannily announcing that the first Beanie Babies would soon be withdrawn from shelves, making them collector's items virtually overnight. The strategy of deliberately producing limited numbers of each new design created a sense of hysteria among fans and fuelled a buoyant collector's market. Even today, some of the first Beanie Babies sell for hundreds and, in some cases, thousands of dollars.

Possibly the rarest Beanie Baby in the collector's world is a royal-blue version of Peanut the Elephant. During production, Ty Warner spotted the elephant had been made with the wrong colour fabric and immediately switched to the correct light-blue colour. Only around 500 of the dark-blue elephants

ever made it on to the shelves and collectors will now pay as much as $1,500 for a pristine condition royal-blue Peanut elephant with the tag still attached.

Despite their collectible nature, Beanie Babies were also popular in their own right as stuffed toys for children and not everyone was interested in their resale value. Consequently, many rare and valuable Beanie Babies still lurk in old toy collections with their value unrecognised, sometimes appearing in charity shops or at car boot sales for bargain prices.

While the Beanie Baby craze was reaching its peak in the mid-to-late nineties, another toy fad arrived in the UK that would foreshadow later generations' slavery to smartphones: the Tamagotchi. The Japanese-designed hand-held digital pet was created specifically to be as demanding and time-consuming as caring for a real pet, and resulted in both children and adults spending way too much time looking after their Tamagotchis when they really should have been doing other things like working, sleeping or checking the traffic was clear before crossing the road.

The little egg-shaped hand-held device had a tiny black and white screen and a few buttons and, through rudimentary pixellated graphics, depicted a pet alien that would initially hatch from an egg and then grow through the various stages of being a baby, child, teen and finally an adult. In order to facilitate the healthy growth of the alien, you were required to feed it, play with it, discipline it and even toilet train it, and give it medical attention when it was sick. Various meters would show you the happiness, hunger levels and so on that you needed to continually monitor and react to if you were to prevent your pet alien becoming an unhappy and sickly individual heading for a premature death.

While the concept seemed like a fun idea to begin with, the incessant demands of the Tamagotchi began to wear and each time it beeped at you requesting your attention, it took one step closer to being smashed into a thousand tiny pieces. Like a real baby, though, people felt a responsibility to look after their virtual pets and simply couldn't ignore the sad little bleeps. They felt obligated to make sure the virtual pet was cared for adequately, resulting in people taking their Tamagotchis everywhere with them. Of course, it didn't take long before Tamagotchis were banned from most schools and pupils blamed teachers for the untimely deaths of their virtual friends.

For some, the thought of leaving their Tamagotchi at home, virtually crying and virtually hungry, was simply too much responsibility to bear and a Tamagotchi baby-sitting service sprung up with a kind of virtual crèche that took care of your Tamagotchi while you were at school or work.

Tamagotchi was the number one selling toy for Christmas 1997 but by the following Christmas it had been usurped by another another electronic pet, the Furby, who took the number one spot in 1998. The Furby was a gibberish-talking furry owl/rodent hybrid which had the ability to interact with its owner to a certain degree. Out of the box, the brightly coloured and large-eyed Furby would speak in its own language called Furbish and over time would 'learn' English and start to replace the Furbish phrases with English phrases.

As well as talking to humans, Furbies were able to communicate with one another using a built-in infrared port located between their eyes, as well as move their eyes, mouth and ears. While they were relatively limited in both their ability and their 'intelligence', the toys were an enormous success, partly

because of their low price of around £25, and sold over 40 million units during the first three years of production alone.

In 1999, Sony released its far more advanced electronic pet, the Aibo robotic dog – but with an original price tag of around $2,500, this was not a competitor to the Furby. Despite all 3,000 original units selling out within twenty minutes of going on sale, the Aibo was mainly purchased as a toy for affluent and somewhat nerdy adults rather than for under-appreciative children who would likely break the valuable robotic dog in minutes.

Aibo was an intelligent robot dog that was seen as a trainable companion, mimicking the personality and behaviour of a real dog without requiring the owner to clean up after it. Aibo could bark, whine and growl, play with a ball and respond to over one hundred different voice commands. The robot dog was bristling with sensors including infrared, accelerometer, temperature and touch sensors, as well as a digital colour camera and microphones.

Fortunately for all those who had a hankering for a robotic pet dog like Aibo but couldn't afford or justify the eye-watering price tag that accompanied it, a company called ToyQuest responded by producing a much-simplified robotic puppy called Teksta (sometimes known as Tekno) who displayed much of the same pseudo-intelligence and characteristics as Aibo but with a price tag of under £40. It became an instant hit and took the number one spot for the best-selling toy in Christmas 2000.

In previous Christmases, the top spot had been taken by the Teenage Mutant Ninja Turtles characters (1990), Nintendo Game Boy (1991), Thunderbirds Tracy Island play set (1992), Barbie dolls (1993), Power Rangers action figures (1994),

A Furby robotic toy that bears more than a passing resemblance to Mogwai in the film *Gremlins*.

Pogs (1995), Buzz Lightyear figure (1996), Tamagotchi (1997), Furby (1998) and then finally, in 1999, the decade culminated with Pokémon trading cards taking the number one spot.

The final Christmas of the nineties was a very special occasion since, as well as being the last of the decade, it was also the final Christmas of the century and of the millennium. At the very beginning of the century, Christmas had been a far more modest affair with little Dickensian children dressed in rags given a piece of lint and a clip round the ear as their Christmas presents. But by the end of the century, everything had changed and the children of the nineties were spoiled beyond measure with gift after gift of nineties goodness.

While Pokémon trading cards were the most popular gift of 1999, Furby Babies would have likely taken the top spot had the shelves not been cleaned absolutely bare in the run up to

Christmas. WWF Wrestlers were the next most popular gift at number three in the top ten toy charts, followed, somewhat surprisingly, by the Who Wants To Be A Millionaire board game at number four. Christmas afternoon 1999 in the UK was undoubtedly filled with people pretending to be Chris Tarrant, asking each other 'Is that your final answer?' and imitating the music that comes between questions.

At number five were the revolting and slimy Alien Eggs that looked disturbingly like foetuses in mucus, which obviously thrilled the same sort of little boys that liked Monsters in my Pocket, and at number six Beanie Babies continued to be massively popular after six years as a top toy. The Silver Speeder Action Man car with built-in auto-homing missiles came in at number seven, followed by Tweenies characters Jake, Bella, Fizz, Milo and Doodles at number eight. Sleeping Beauty Barbie was the ninth most popular toy and the Baby Annabel doll took tenth place.

Not only did we have the best toys of any generation that came before us but we set the standard for the toys of the future generations. Our toys became the benchmark for what the children of the world expected in the new millennium. Nineties toys were just the right mix of traditional and electronic, the perfect balance of entertaining and educational, and the ideal blend of real world and virtual. We were the kids of the nineties and our toys were the best!

Seven

TECHNOLOGY

Imagine a world without smartphones. A world without Google, Facebook and Twitter. A world without emails and text messages, Internet TV and video calling, and a world where there was nothing to do while you wait for the bus except talk to the person next to you. This was the not-so-distant world of the early nineties.

We didn't have WiFi, social media or sat nav, and there were no such things as selfies, hashtags or viral videos but, at the time, we were the most technologically advanced generation the world had ever seen.

While the digital revolution had begun a decade earlier, it wasn't until the nineties that all the exciting new technologies had matured enough to become accessible to the general public. Enormous advances in the miniaturisation of electronic devices combined with exponential increases in computing power and economies of scale in production began to put increasingly advanced technology in the hands of ordinary consumers and the ordinary consumers couldn't get enough of it.

At the beginning of the decade, home computers were still seen as a bit of a gimmick – something kids liked to play

games on perhaps but of no real practical use to most people. Computers were expensive, difficult to use and had such rudimentary graphics that it took the overactive imagination of children to find any real enjoyment in the limited selection of games that were available.

Those with some foresight had seen that the children of the nineties would face a future where computers were an increasingly important part of their lives and so an effort was made to introduce some form of computing lessons in schools across the country. Consequently, most schools were kitted out with a handful of BBC Micro computers that none of the teachers knew how to operate. In fact, the majority of teachers were still struggling to figure out how to operate the old Betamax video cassette player and enormous wood-panelled television that would be wheeled into the classroom from time to time when the teacher wanted a break from teaching. Inevitably the somewhat frustrated teacher would, after ten minutes of random button pushing, call on the help of the pupils to show them how to turn on the TV and press the play button.

So when it came to operating an advanced piece of equipment like a BBC Micro computer that was literally covered with buttons, many teachers opted to simply let the pupils educate themselves rather than try to get involved. As a result we spent many a lesson typing in increasingly smutty variations on the old classic:

```
10 PRINT 'This is boring'
20 GOTO 10
```

Things became a little more exciting when a fleet of new Acorn Archimedes computers arrived in the schools with

advanced graphics, mice and a powerful 8MHz processor that allowed us to spend our computer lessons playing the classic game *Lander* which featured a mouse-controlled space ship that flew around a 3D landscape shooting alien spacecraft out of the sky. While there was clearly little educational benefit to a bunch of children spending an hour playing computer games, many teachers simply didn't have adequate training to make use of this new technology and instead used computing lessons as an opportunity to take a welcome coffee break.

At home we had somehow managed to persuade our parents that there was some kind of educational benefit to upgrading our home computer. I remember explaining to my poor parents, who knew no better, that investing in an Amiga 500 computer was an investment in my education and, consequently, one Christmas my brothers and I became the over-excited recipients of a shiny new Commodore Amiga 500 computer – the best gaming computer on the market at the time.

The Amiga came with a whopping 512kB of RAM, compared to the measly 48kB in my old rubber-keyed ZX Spectrum, and had space to install a further 512kB memory expansion pack, allowing us to play even more advanced games.

My parents, completely taken in by the belief that this was an educational opportunity, had also pushed out the boat and invested in a 24-pin dot matrix printer so that I could print out all the reams of schoolwork and studies they thought I was going to be doing.

The truth is that, while technically capable of many noble academic pursuits, the Amiga 500 was first and foremost a powerful games machine and this is what my brothers and I used it for. We spent so many hours playing *Bubble Bobble*,

Lemmings and *Out Run* that it actually had a negative effect on my education. Eventually my parents realised they had been duped, but by this time it was too late to return the computer and so instead they came up with the ingenious idea of rationing it by only allowing us to use the computer for the same amount of time that we had spent reading books that day!

Around the same time that my brothers and I were coming up with inventive ways to falsify our reading records to earn more computer time than we deserved, a battle had begun between Amiga 500 and Atari ST owners. The Atari ST was an equally capable machine and fairly matched in terms of specification against the Amiga, but Atari owners claimed that it was superior because of its built-in MIDI ports and better sound quality. Because of the MIDI ports, the Atari ST became extremely popular with musicians who could easily connect their synthesisers and use the brand new Cubase music software to create outstanding compositions.

While both the Amiga 500 and Atari ST were business-capable machines, the PC dominated the workplace. At the beginning of the nineties, Windows was still at version 2.11 and was designed to run on the 286 and 386 Intel chips which only ran at speeds of up to 40MHz; it wasn't until 1995 that an add-on for Windows 95 was released that gave users the opportunity to access the Internet with the Internet Explorer V1.0 web browser.

Apple Macintosh computers only represented a very small percentage of the business computer market and were largely used by graphics professionals partly because the Macintosh was the first computer to truly allow for digital typography. Also, the industry-standard design and desktop publishing packages Photoshop and QuarkXPress were first released for

Macintosh computers and several years passed before Windows versions were produced, giving plenty of time for Apple to gain a dedicated niche following.

Personal and business computing evolved somewhat predictably throughout the early nineties in a series of progressive steps that increased computing power and storage and reduced size and cost of components. But in 1998 a truly revolutionary new computer was released by the beleaguered Apple, who had been suffering a series of setbacks that threatened their long-term future.

On 6 May 1998, the company announced the birth of the iMac G3 computer which was dramatically different from any other computer that had ever come before it. Instead of the standard beige, grey or black box connected to a separate display, this was a bright blue all-in-one with computer and screen combined in a rounded, futuristic-looking unit. Even

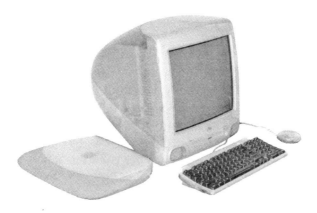

An original Apple iMac in tangerine orange with matching keyboard and 'hockey puck' mouse. Next to the iMac is a 'clamshell' iBook laptop computer.

the keyboard and mouse had been redesigned with the same 'Bondi-blue' and translucent plastics used on the body of the iMac, and the circular mouse quickly became nicknamed the 'hockey puck'.

As well as the groundbreaking design which came from the creative mind of Sir Jonathan 'Jony' Ive, the astonishing new computer featured a built-in 56k V.90 modem – the fastest available at the time – that allowed it to connect directly to the Internet without any additional hardware. In fact, the letter 'i' in iMac actually stands for 'Internet', and Apple had decided to make the iMac so easy to use that it would only require two steps to set up and connect to the Internet. The advertising campaign voiced by Jeff Goldblum proudly declared, 'There's no step three!'

This was the start of the reversal of Apple's fortunes, which had been in decline for some time. The iMac G3 was in production for five years and was continually updated with a total of thirteen different colour options along with the addition of a slot-loading optical drive, FireWire and the option of airport wireless networking.

At the same time that desktop computers were undergoing something of a revolution, portable computers were becoming more and more advanced as well, so that, by the early nineties, the large 'luggable' computers were now small enough to sit comfortably on your lap and earn the name 'laptop' computers.

In 1991 Apple released its stylish and powerful 'PowerBook' laptop computer, which had a black and white display and a trackball to control the position of the cursor. By 1993 a colour display was launched and in 1994 the first integrated laptop trackpad replaced the trackball on the PowerBook 500 series. By the end of the decade, the laptop had evolved so

much that it now took its design cues from the colourful iMac; the new iBook laptop released in 1999 featured a brightly coloured clamshell design with built-in wireless networking.

Of course, the new multi-coloured computers with increased processing power and easy-to-use software were nothing in comparison with the invention that truly turned computing on its head in the nineties: the World Wide Web.

Before going any further, it's worth clarifying a very common misunderstanding which is that the Internet and the World Wide Web or just 'the Web' are the same thing. They're not, and the two terms shouldn't be used interchangeably as they invariably are. Simply put, the Internet is the name given to the infrastructure of computers, cables, routers, switches and so on connected to one another that allows one computer to talk to another. On this network, various different services operate, including emails, streaming video and music, file sharing and, of course, one of the most popular services all, the Web, which is a collection of websites accessed through a web browser.

The Internet has actually been in existence for far longer than the Web and originally dates back to the 1960s, when the first computer networks were created allowing two or more computers to 'talk' to each other. But it wasn't until much later, in August 1991, that the World Wide Web made its public debut when English scientist Tim Berners-Lee shared his brainchild of a global hyperlinked information system.

Of course, in the early days, very few people had access to the Web and there were far fewer websites available than there were users, but the popularity of the Web with those in the academic community gradually led to an increased awareness of the service with the general public. I remember my dad

reading me an article out of the newspaper that talked about this thing called the 'Internet Information Superhighway' (an early nickname for anything to do with the Internet) which would one day allow us to access information through our computers in a similar way to Teletext on the television. The understatement of the article was almost as profound as Alexander Graham Bell's optimistic prediction that 'One day every major city in America will have a telephone'.

However, our interest was piqued and in 1994 the first Cyber Cafes started to appear where people could pay by the minute to access the Web. At this time, the Web was still accessed through dial-up modems on a regular telephone line that placed a phone call to the Internet Service Provider (ISP), and so you were charged for the price of the phone call as well as the service fee for the ISP. You had to be very careful to make sure you disconnected from the Internet when you had finished otherwise the line would remain open indefinitely, running up enormous phone bills.

As word spread about the benefits and possibilities of the Web, more and more people began to take an interest and of course it wasn't long before entrepreneurial businesses had begun to take advantage of the Web as an opportunity to increase their marketing presence and create websites that acted as a sort of digital brochure to advertise their companies.

By mid-1994 there were an estimated 2,738 websites, which included such gems as the Trojan Room Coffee Pot, which was the world's first webcam pointed at the coffee machine in the old Computer Laboratory at the University of Cambridge. The idea had originally been to save people a wasted trip to the room if they could see from their computer screen that the coffee pot was empty, but when the camera was connected to

the World Wide Web it became an unlikely Internet sensation that continued to draw in thousands of observers until 2001. But the growth of the Web was so profound that just a few months later, at the end of 1994, the number of websites was estimated at over 10,000.

1994 was arguably the year of the Web's tipping point, when the technology transitioned from a niche academic tool to a public and commercial resource available to everyone. The famous Netscape Navigator web browser debuted in 1994 with Microsoft's competing browser Internet Explorer arriving shortly after. Computer magazines suddenly started including 'Get connected to the Web' CDs on their front covers with guides explaining how to set up your home computer to access the Web through companies like AOL and CompuServe. Online shopping giant Amazon made its first tentative steps towards world domination, with eBay following in 1995.

As the number of websites available increased exponentially, search engines were required to navigate the increasing wealth of resources available and early search engines included Excite, AltaVista, Infoseek, Yahoo, Lycos, Hotbot and Webcrawler. It wasn't until much later, in 1998, that Google arrived on the scene and began to rapidly consume the market share of all the other search engines.

By the end of the decade, there were an estimated 3 million-plus websites and over 280 million users, with that number increasing at an astonishing rate every day.

As computers became more and more widely used throughout the nineties and mankind increasingly relied on computers for everything from banking, aviation and business to retail, healthcare and even agriculture, a vague spectre began to take

shape in the form of something called 'The Millennium Bug'. At first the talk was of a computer bug that may or may not even exist and that might prove to be a headache for some computer programmers. But by the time the media got their hands on the story it had turned into a terrifying apocalyptic vision of failing computers plunging the entire world into chaos with aeroplanes dropping out of the sky, hospital life-support machines shutting down and the financial systems going into meltdown.

At its heart, the Millennium Bug was a remarkably simple issue. Early computers had such limited memory that the year 1995 was written as just 95 to save a couple of digits. This was all well and good until the year 2000, when 00 would be interpreted as 1900 and the resulting confusion could cause the computer to crash or behave strangely.

Businesses began preparing several years in advance updating their computer systems to ensure they weren't caught out and, as the year 2000 approached, governments around the world warned businesses and the general public to take precautions and prepare for the unknown consequences. Margaret

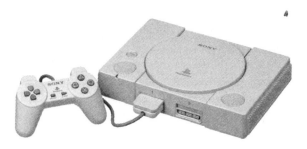

The original PlayStation (now known as the PS1) from Sony, released on 29 September 1995 in Europe.

Beckett, the minister in charge of millennium preparations, said the bug had the capacity to 'wreak havoc', and Richard Madeley ran a Millennium Bug feature on *This Morning* where he recommended stockpiling at least ten weeks' worth of food along with candles and medical supplies.

As public alarm began to spread, there was a very real danger that people's panic could be more dangerous than the bug itself. If people worried about the collapse of the financial systems and withdrew all their money from the banks, for example, then the banks would collapse just like the situation with Northern Rock bank in 2007.

As the big day approached, no one really knew what to expect and as the clock struck midnight around the world on New Year's Eve, everyone braced for the worst. We watched New Zealand and Australia welcome the new millennium first without apparent disaster, and as midnight approached Britain our confidence grew and we hoped we would be able to enjoy our millennium party without disruption.

Obviously there was no apocalypse. Everything ran pretty smoothly and the Y2K preparations had been a success. How disastrous things would have been if we hadn't prepared is a matter of some debate, with cynics saying that there never was any real threat and that it was all a money-making exercise for IT guys who had a few years of great business fixing the 'problem'.

Having said that, a few problems did emerge which showed that the potential had definitely been there for some fairly life-altering consequences if left unchecked. In the UK over 150 pregnant women were given the incorrect results for tests for Down's Syndrome, and a number of credit card transactions failed. In the US, the official timekeeper, the Naval Observatory,

reported the date as 19100 and in Japan a system collecting flight information for small planes failed. Fortunately this was about as serious as it got, though, and the majority of IT guys had a very quiet and very well-paid job babysitting computers on the evening of 31 December 1999.

While the revolution in computing and the birth of the World Wide Web tend to dominate the technological landscape of the nineties, advances in consumer electronics were also accelerating at unprecedented rates, giving rise to an abundance of new technology such as digital cameras, mobile phones, MiniDisc players, MP3 players, DVD players and advanced games consoles like the Sony PlayStation.

The very first digital camera in the UK was the Logitech Fotoman, which arrived in 1990 at a price of £499 and had the ability to take tiny 320 × 240-pixel black and white images and store them on its internal 1MB of memory. There was no real practical application for this camera and it was seen by many as a novelty item, reflecting the views of some in the photographic industry who believed digital photography would never catch on.

By 1994 digital photography had progressed somewhat and was beginning to be taken seriously by some people, including Apple who partnered with Kodak to make the Quicktake 100 which produced 640 × 480-pixel images in colour and featured a USB connection so that photos could be easily transferred to a computer.

It took the majority of the decade before digital photography technology had progressed to a point where it could be seen as coming even close to competing with traditional film-based cameras. In 1999 Nikon released the D1 camera, which was the first professional-style SLR camera to be specifically

redesigned, from the ground up, as a fully digital camera. It featured a respectable 2.7-megapixel sensor and 4.5 frames per second shooting, which made even the most cynical, old-school photographers sit up and take notice.

In 1992, music technology saw a new innovation with the introduction of Sony's new magneto-optical disc, the MiniDisc, which was largely used for audio recording and playback. The MiniDisc was the first viable competitor to the established Compact Disc (CD) format since the MiniDisc offered recording capabilities that CDs, at the time, didn't offer.

The battle between CDs and MiniDiscs didn't last long. The MiniDisc equipment was prohibitively expensive and, while it gained a modest loyal following, its death knell sounded early in 1998 with the launch of the world's first portable MP3 player.

Of course, the nineties also bore witness to the widespread use of mobile phones. We started the decade with only a handful of 'Yuppies' carrying enormous, brick-sized mobile phones that cost a small fortune both to buy and to operate, but over the course of just ten years, mobile phone technology had advanced so rapidly that both the size and price reduced dramatically, and mobile phone ownership became both affordable and practical for the majority of people. By 1999 around 44 per cent of households in the UK had a mobile phone compared with just 16 per cent of households in 1996. And within a further fifteen years the market had reached virtually complete saturation, with 95 per cent of households having a mobile phone.

The most popular mobile phones of the nineties were the Motorola StarTAC, which has the distinction of being the first

ever 'flip phone', and the Nokia 3210 which, at the time of writing, is still the fourth best-selling phone of all time.

While these two phones featured cutting-edge technology for the time, neither of them included a touchscreen, colour display, camera or Internet access. They really were just mobile telephones with SMS text messaging. The smartphone didn't arrive until some time later and, for now, the gap in the market for a hand-held computer was filled by so-called Personal Digital Assistants (PDAs) such as the Palm Pilot. And, of course, as mobile phones grew in popularity, belt-clipped pager sales decreased proportionately.

Towards the end of the nineties and into the early part of the new millennium, people began to suffer from a whole new 'first-world problem' – having too many devices to carry. Heading off for a long weekend where you needed to stay in touch with the office, you might take with you a digital camera, separate camcorder, mobile phone, MP3 player, laptop computer, PDA, GPS system and a whole bundle of different chargers and cables. We started hearing a lot of talk about the idea of something called 'convergence', which was the utopian dream that someday there would be a single device that performed all the functions of the numerous individual devices so that we only had the one gadget to carry around with us. Of course, this dream was duly fulfilled in later years but in the nineties we had to suffer the terrible burden of unsightly bulging pockets stuffed full of gadgets.

In addition to the plethora of new gadgets and advances in consumer technology, the scientific and academic worlds saw technological breakthroughs in the nineties that included the development of genetically modified food, the use of DNA testing in criminal forensics, the launch of the Hubble Space

Telescope, the birth of Dolly, the world's first cloned sheep and the arrival of a new wonderdrug called Viagra.

While genetic engineering was something that had been practised since the early seventies, fears about health risks and environmental harm prevented the commercial production of genetically modified food until 1994, when the 'Flavr Savr' tomato was approved for release to the public and included an inserted antisense gene that delayed ripening. Shortly afterwards a number of other foods were approved for release, including a potato that produced its own pesticide and a virus-resistant squash.

Simultaneously, genetic research was being carried out into animal cloning, with the result that in 1996 the world's first successfully cloned mammal, Dolly the Sheep, was born through a process of something called somatic cell nuclear transfer. Of course, the question asked by most people was whether this heralded the beginning of an era in which human beings would start to be cloned or genetically modified, but the official response was that this technique was not currently viable for human cloning.

It did, however, raise the interesting potential for the resurrection of extinct species such as dinosaurs – a subject which had already caught the imagination and, in some cases, sparked the fears of the public in the film *Jurassic Park* (1993). While an extinct wild mountain goat, the Pyrenean Ibex, was successfully recreated in 2009 using a similar technique, the young animal died shortly after birth due to a physical defect in its lungs. While Dolly the Sheep's legacy has resulted in significant advances in the world of animal cloning, for the time being we don't have to worry about the return of the velociraptor.

As well as genetic engineering of crops and cloning of animals, advances in our understanding of genetic science also led to the accidental discovery of something called 'DNA profiling', where a small sample of blood, hair or other bodily tissue or fluid could be analysed to produce a DNA 'fingerprint' unique to that individual.

This resulted in a breakthrough in forensic criminal science as scientists were now able to take blood samples from suspected criminals and compare their DNA profile with that of samples found at the scene of a crime, with extremely high accuracy. As well as being used to solve current crimes, the new technology was retrospectively applied to older criminal cases, resulting in the arrest and conviction of numerous murderers and other criminals who had previously escaped detection.

Not only was this new technology used to convict criminals of crimes in cases where there would previously have been no evidence, it was also used to exonerate people wrongly convicted of crimes they did not commit. In the USA at least 300 convicted criminals, including seventeen death-row inmates, have been set free after post-conviction DNA profiling proved them to be innocent or at least called into question the evidence that had been used to convict them. In one case, the incorrectly incarcerated man had already served thirty-one years behind bars.

This new technology also finally gave us a way to establish relationships between family members beyond all doubt. In cases where the parentage of a child was in question, the true father of a child could at last be established, resulting in some happy cases of family reunion and undoubtedly many other cases of awkward embarrassment.

One of the first great scientific achievements of the nineties, though, was the launch of the Hubble Space Telescope into low Earth orbit in 1990. The enormous telescope, with its 2.4-metre diameter mirror, was transported into space inside the Space Shuttle Discovery and was designed to provide a window on to the farthest reaches of the universe free of obstruction and distortion from Earth's atmosphere.

However, within weeks of the launch of the telescope, a serious problem was discovered when the images it sent back were significantly lower quality than expected. Detailed analysis showed that the primary mirror had been polished to the wrong shape and, despite it being the most technically advanced optical mirror ever made, it was misshapen by a tiny but significant amount. It was inconceivable to return the telescope to Earth for repairs so an alternative solution

These are the MiniDisc cartridges from Sony that may well have replaced CDs if MP3 players hadn't been invented.

was proposed in which additional optical components could be added to the telescope during a servicing mission which would counteract the flaws in the mirror in much the same way as giving it a pair of spectacles.

In 1993 seven astronauts were sent aboard the Space Shuttle Endeavour on a mission to repair the Hubble Space Telescope and the team spent ten days spacewalking with a toolbox full of rusty spanners and Allen keys, and a rough set of Ikea-type instructions translated from Chinese into pidgin-English. While one space engineer did all the work fixing the telescope, the other six astronauts floated around nearby trying unsuccessfully to lean on a shovel in outer space while drinking mugs of space tea and eating space garibaldis. Occasionally one of the astronauts would pause to gesture and wolf-whistle at the female astronauts aboard the International Space Station as it whizzed past. Despite the heavy space outfits worn by the astronauts, all seven of them wore the lower half sufficiently loose that when they bent over they would reveal the space equivalent of 'builder's bum' simply known as 'astronaut's bum'.

Despite a lengthy delay in the repairs while one of the astronauts went to the space merchant to pick up some spare parts, the mission was a success and in early 1994 the first razor-sharp images were sent back to Earth, giving us some of the most detailed and astoundingly beautiful photographs of the furthest objects in space.

While not quite on the same scale as the optical technology behind the Hubble Space Telescope, the nineties also brought us a brand new visual technology in the form of Magic Eye pictures. The strange-looking images, most often sold as posters or as collections in books, appeared to be nothing but abstract shapes and patterns or, in some cases, were like the

'snow' effect you used to get on analogue televisions when there was no signal. However, if you stared at the image for long enough and let your eyes relax and look 'through' the image, an amazing 3D picture would magically take shape before your very eyes.

Technically called autostereograms, the Magic Eye pictures were actually a composite of two different images, one for the left eye and one for the right which, when viewed correctly, merge together and trick our brain into perceiving depth. While stereoscopic images had been in existence for some time, they had previously required some kind of viewing device or lenses to create the desired effect, but the Magic Eye images could be viewed by simply relaxing your eyes and staring into space.

At the peak of its popularity, the Magic Eye series of images was so popular that they began to make appearances in popular TV shows of the time, including an episode of *Friends* where Ross can't spot the Statue of Liberty and in *Seinfeld* where Elaine's boss neglects an important business merger while he tries to find the hidden spaceship in the patterns. Some people seemed to be unable to ever see the hidden images in the Magic Eye pictures and would get frustrated staring for hours at the images with no result, while others would see them immediately. The New Age movement even adopted the Magic Eye images as a form of meditation that encouraged you not only to relax your eyes but also your mind. Then, as suddenly as the Magic Eye images had appeared on the scene, they disappeared again.

The nineties was a time of rapid technological progress and, especially after the World Wide Web facilitated improvements in knowledge sharing and communication, the rate of scientific

and technical innovation accelerated beyond anything the world had ever seen before.

At the beginning of the decade the Web didn't exist and neither did search engines, web browsers or laptop computers. Virtually no one had mobile phones and there were no such things as DVD or MP3 players. But by the end of the decade, we had them all. Every day brought news of some new gadget or innovation and the rate of change was so fast it was hard to keep up with the progress. Magazines like *T3* and *Stuff* launched in the nineties in an effort to sift through the mountains of new technology and present the highlights to a generation hungry for gadgets and yet, ironically, even printed magazines were now being replaced by new technologies such as blogs and e-readers.

We were still in that honeymoon period with our technology where we had just the right amount to improve our lives but not so much that it dominated and controlled us. As children of the nineties, we were able to enjoy all the benefits of this exciting new world of technology without being compelled to spend all our time staring at smartphones and updating our social media. We had the best technology the world had ever seen and we were free to enjoy it.

Eight

BIRTHS, MARRIAGES AND DEATHS

The morning of 1 March 1994 began like any other in the misleadingly named city of London, in Ontario, Canada.

The Canadian folk dressed themselves in head-to-toe denim as usual and made their way through the snow to Tim Hortons for their morning coffee and Timbits, pausing only to apologise to a few strangers on the way. As they sat watching ice hockey on the TV screens and drinking maple syrup straight from the bottle, the Canadian public were completely unaware that a child had just been born in the nearby hospital. A child who would change the world of pop music forever and a child who would be loved and despised in equal measure. A child whose name was Justin Bieber.

While scientists estimate that several new people were born in Canada during the nineties, Justin Bieber was almost certainly the most famous and his birth came just days after that of wild-haired pop prince Harry Styles who was born in England – home of the real London.

Numerous other infant celebrities were born around the world in the nineties including provocative singer Miley Cyrus (born 1992), whose career began as an actress starring in the Disney TV series *Hannah Montana* alongside her dad Billy-Ray Cyrus ('Achy Breaky Heart'). Also born in the nineties were singers Rita Ora (1990), Iggy Azalea (1990), Ed Sheeran (1991) and Zayn Malik from One Direction (1993), Selena Gomez (1992), Ariana Grande (1993) and Jaden Smith (1998), the son of Will Smith, actresses Emma Watson (1990) from the *Harry Potter* movie series, Kristen Stewart (1990) and Cameron Bright (1993) from *The Twilight Saga*, Dakota Fanning (1994), Jennifer Lawrence (1990) and Freddie Highmore (1992), who played Charlie in the 2005 version of *Charlie and the Chocolate Factory*.

Of course, during the nineties, we didn't hear much about these young stars-to-be since, at this point, Justin Bieber's entire musical repertoire still only amounted to a high-pitched rendition of the national anthem 'O Canada' and a handful of nursery rhymes. Likewise, Kristen Stewart, as a young girl, hadn't quite perfected her neutral-yet-slightly-sneering facial expression that would become her trademark look for all emotions in future acting roles. And Ed Sheeran was still just an adorable ball of ginger fur.

So instead we can reminisce about some of the more notable marriages that took place during the decade, starting with the doomed second marriage of squillionaire businessman Donald Trump, which took place shortly after his divorce from first wife Ivana. On 20 December 1993 Donald Trump married actress Marla Maples, who had been a runner-up in the Miss Georgia USA competition in 1984. Together they had a child, Tiffany Trump, who was apparently named after the famous jewellery store but, unfortunately, the ill-fated

marriage only lasted six years before they were divorced in 1999.

Divorce has always been common in celebrity marriages and it was certainly no different in the nineties. In 1992 music legend Whitney Houston, who had previously had a relationship with actor and comedian Eddie Murphy, married singer Bobby Brown. This was the same year that Whitney had a smash hit with her version of the Dolly Parton song 'I Will Always Love You', which became the tenth best-selling song of the nineties in the UK, selling around 1.3 million copies in total. Unfortunately this marriage did not last either and Whitney and Bobby divorced in 2007.

Shortly after Whitney's wedding, it was Mariah Carey's turn to attempt a successful wedding when she married Tommy Mottola in 1993. However, after less than four years together, Mariah announced their separation and by 1998 they too were divorced. Cindy Crawford's marriage to Richard Gere in 1991 fared no better, lasting just four years as well, and Will Smith's brief attachment to Sheree Zampino in 1992 resulted in the birth of his first child, Willard Carroll 'Trey' Smith III, but the marriage ended in divorce in 1995.

However, it was not all doom and gloom in the world of celebrity relationships since Will Smith went on to marry Jada Pinkett and have two further children and a long-lasting marriage, while Sarah Jessica Parker (*Sex and the City*) married Matthew Broderick (*Ferris Bueller's Day Off*) in 1997 and, at the time of writing, they too are still happily married with three children.

Julia Roberts (*Pretty Woman*) has an interesting wedding story to tell since she got engaged to Kiefer Sutherland (*Flatliners*) but in 1991 ended up doing a runner just three

days before their wedding was due to take place. As is the way with Hollywood weddings, the event was planned to be a spectacular affair and they were supposed to be married on 20th Century Fox's Soundstage 14, which was in the process of being decorated in the style of a garden paradise. The bridesmaids had already collected their dresses and designer shoes, and Julia Robert's $8,000 wedding dress was awaiting collection. One hundred and fifty guests had been invited and were prepared for the big event.

In a turn of events that foreshadowed her starring role in the 1999 movie *Runaway Bride*, Julia Roberts allegedly got a friend to phone Kiefer Sutherland to tell him the wedding was off before hopping on a plane to Ireland a few days later with Kiefer's so-called 'friend' Jason Patric. The relationship with Patric didn't work out either and in 1993 she married country singer Lyle Lovett. Two years later they too were divorced and she began a doomed relationship with actor Benjamin Bratt. By 2002, though, it appears that Julia Roberts had settled down somewhat and she married cameraman Daniel Moder to whom she is still married to this day.

One of the more 'eyebrow raising' weddings of the nineties was that of 26-year-old former Playboy model and actress Anna-Nicole Smith and 89-year-old billionaire oil tycoon J. Howard Marshall. The sixty-three-year age difference between the pair caused much speculation and led to suggestions that perhaps Miss Smith was marrying him for his money. Of course, this accusation was fiercely contested and Anna-Nicole Smith declared her sincere love for her octogenarian husband, despite revealing that she never actually lived with him or consummated their marriage.

When considering this situation, I am put in mind of the famous TV interview in 1995, for which Caroline Aherne played 'Mrs Merton' in the eponymously titled comedy chat show and asked her guest, Debbie McGee: 'What first, Debbie, attracted you to millionaire Paul Daniels?'

When J. Howard Marshall died just thirteen months after his marriage to Anna-Nicole Smith, one of his sons began a dispute into Smith's claim that she was entitled to inherit half of the $1.6 billion estate. A protracted legal battle ensued which continued right up until Smith's untimely death in 2007. The unfortunate actress who appeared in films including *The Hudsucker Proxy* (1994) and *Naked Gun 33⅓: The Final Insult* (1994) reportedly died in a Hollywood hotel room as the result of an accidental overdose of prescription medicines.

While the Americans had their fair share of celebrity weddings in the nineties, we in the UK had one thing they didn't: royal weddings! In 1992 Princess Anne, the queen's only daughter, married Captain Timothy James Hamilton Laurence at the small parish church in Crathie, Scotland, where the royal family regularly worship while residing at nearby Balmoral Castle. And in 1999, Prince Edward, the youngest son of the queen, married Sophie Helen Rhys-Jones at St George's Chapel, Windsor Castle. The couple met at a charity event in 1993 when Sophie was working as a public relations executive at Capital Radio. A relationship began and eventually, after a protracted five-year plus courtship, they announced their engagement with Sophie showing off a flashy £100,000 diamond engagement ring. Rather than choosing an extravagant wedding at Westminster Cathedral or St Paul's Cathedral like his brothers, Prince Edward opted for a more intimate service

at the chapel within the grounds of Windsor Castle with relatively low-key media coverage.

Also in 1999, the same year as the royal wedding of Prince Edward, we saw the faux-royal wedding of the alternative Prince and Princess of the People, Posh and Becks. Victoria Adams, better know as Posh Spice from the Spice Girls, met Manchester United footballer David Beckham at a charity football match in 1997 and had no idea who he was at first since she had no interest in football. David Beckham, however, knew who Victoria was and showed a keen interest in her, requesting a follow-up meeting with her after the event. In 1998 the pair announced their engagement and the press, who love coming up with imaginative nicknames for celebrity couples, immediately dubbed them 'Posh and Becks'.

Their wedding was reportedly an extravagant and expensive affair costing an estimated £500,000 and took place at Luttrellstown Castle in Ireland. Strengthening their image as alternative royalty, they actually sat on golden thrones at their wedding reception and Victoria wore a diamond coronet specially created for her.

The nineties was a decade that heralded the arrival of many new and exciting stars and witnessed the marriages of numerous others, but it was also a time when we said a sad farewell to some of our heroes and heroines of old. Famous puppeteer and inventor of the Muppets, Jim Henson, passed away in 1990 leaving an outstanding legacy in the TV and movie industry, while leading ladies of the silver screen, Greta Garbo and Marlene Dietrich, took their final bow along with *Breakfast at Tiffany's* star Audrey Hepburn.

Author of children's classics *The BFG* and *Charlie and the Chocolate Factory*, Roald Dahl, turned the page in 1990 and

Freddie Mercury sang his swansong 'The Show Must Go On' before his premature death in 1991. Cheeky British comedian Benny Hill went to meet his maker in 1992, having spent some four decades in the spotlight, enjoying viewing figures of over 21 million at the height of his career. One of the more unlikely fans of Benny Hill was Michael Jackson, who actually visited Hill in London towards the end of his life. Elvis Presley

Kristen Stewart demonstrating happiness, anger, scorn, joy, loathing, excitement and apathy all in a single facial expression.

was also said to have been a big fan of Benny Hill, along with Burt Reynolds, Mickey Rooney and, somewhat surprisingly, Snoop Dogg. In an interview, Mr Dogg said:

> I love Benny Hill. He was one of my favourites of all time. Like, the way Benny did it, he was just amazing … Just seeing how he put songs together and comedy and the timing and the sketches. He was way ahead of his time … I would like to play Benny Hill in the Benny Hill movie. I'll even paint my face white.

What I wouldn't give to watch a film called *The Benny Hill Movie* starring Snoop Dogg as the titular character being chased around by a group of angry women to the sound of the 'Yakety Sax' song. Somehow, I suspect this film will never be made and I will have to rely on my over-fertile imagination to give me mental images of white-faced Snoop Dogg slapping a bald man on the head and singing 'Ernie the Fastest Milkman in the West'.

In 1993, Soviet ballet dancer Rudolf Nureyev left the stage, as did actors River Phoenix and Brandon Lee. Phoenix had achieved fame in movies including *Explorers* (1985), *Stand by Me* (1986) and *My Own Private Idaho* (1991), but he tragically died of a drug overdose outside a nightclub in Los Angeles aged just 23.

Brandon Lee's death was far more unusual and has been the subject of many conspiracy theories and urban legends. While filming the movie *The Crow* Lee, son of martial arts movie star Bruce Lee, was accidentally killed in a bizarre turn of events which can only be described as a morbid case of life imitating art. In the movie, there was a scene where his character was meant to be shot dead with a .44 Magnum revolver provided

One of the few Hollywood couples whose marriages have survived. Sarah Jessica Parker and Matthew Broderick married in 1997, have three children and are still together at the time of writing.

by the props team and loaded with harmless blank cartridges. What the production team didn't know was that, in a previous scene two weeks earlier, the very same gun had been used to fire a real bullet for a close-up shot but the lead tip had actually become lodged in the barrel instead of being expelled. Consequently, when a blank round was fired in the blocked gun, the lead tip of the lodged bullet was shot out with virtually the same devastating impact as if a live round had been used.

Brandon Lee was shot in the chest and suffered a fatal injury, but it took the production crew a little while to realise what had happened since he was meant to act dead in the scene anyway. The only clue that something was wrong, apparently, was that he fell backwards instead of forward as choreographed.

After the incident, the movie was cancelled out of respect to Brandon Lee but eventually it was decided that they would go ahead and finish the project after all but with some alterations. The remainder of the movie required some pioneering CGI techniques for the time to effectively resurrect Brandon Lee's character from the dead to complete the outstanding scenes with a stunt double, and screenplay rewrites accommodating any other difficulties. The completed movie is a dark and disturbing story of supernatural vengeance made even more troubling by the knowledge of what happened during its production.

One of the great losses of the nineties that I personally mourned the most was the tragic early death of Canadian comic acting legend John Candy, whose larger-than-life character was well matched with his substantial physical stature. Having risen to prominence in the mid-eighties through his many supporting roles in comedy films including *Splash* (1984) with Tom Hanks, *Brewster's Millions* (1985) with Richard Pryor and *Planes, Trains and Automobiles* (1987) with Steve Martin, Candy landed the lead role in 1989 with John Hughes' classic *Uncle Buck*, where he plays the obnoxious yet lovable Buck Russell.

Also in 1989 Candy took the lead in the much under-rated detective spoof *Who's Harry Crumb?*, where he played a bumbling yet accidentally brilliant private investigator. The following year, Candy was back in a small supporting role in

another Hughes hit, *Home Alone*. John Candy played the lonely but lovely Gus Polinski – Polka King of the Midwest mentioned in more detail in Chapter 5.

In 1993 Candy had a significant role in the comedy film *Cool Runnings*, which tells the – broadly true – tale of the formation of the Jamaican national bobsleigh team, which actually competed in the Winter Olympics despite an obvious lack of snow and ice for them to train on in Jamaica.

Despite Candy's comic acting talent and his appearances in numerous hit films of the eighties and nineties, his career never really quite took off the way it should have and left him languishing in supporting roles for most of his life. Any opportunity to achieve a real breakthrough was lost in 1994 when Candy suffered a fatal heart attack at the age of just 43.

For many people, though, the most tragic and heartfelt loss of the nineties was that of Diana, Princess of Wales, in 1997. The People's Princess, as she had been known, was killed at the age of just 36 in a fatal car accident in Paris, along with her boyfriend Dodi Fayed and the driver of the car, Henri Paul. The official account of the events is that the car was speeding into the Pont de l'Alma road tunnel in Paris when the driver lost control of the car and collided with a concrete pillar. Apparently, the driver was three times over the French drink-drive limit and the passengers were not wearing seat belts at the time.

On the morning of 31 August 1997, word of the tragic death of Diana, Princess of Wales, spread around the world and an immense emotional shockwave rocked the British public, leading to the most astonishing outpouring of collective grief seen in modern times. Kensington Palace, the official residence of Diana, Princess of Wales, became the focus of public

mourning as a seemingly endless stream of people came to lay flowers, wreaths, cards, candles and messages of condolence at the gates. Over 1 million bouquets were laid outside the palace and into Kensington Gardens. At some points, the floral memorial reached 5 feet in depth. Many people lit a candle and placed it in their window at home as a sign of respect.

In the same way many people say that they remember exactly where they were when they heard of the assassination of JFK, most people will be able to tell you where they were and what they were doing when they heard that Diana, Princess of Wales, had died.

For me the memory is very clear, coming downstairs for my breakfast and being met by a friend who told me the news. I immediately turned on the news and watched in disbelieving horror as the newsreaders discussed the events of the past few hours. I turned on the radio as I drove to work and was surprised to discover that the normally lively Radio One was playing a sombre and melancholic mix of music including some classical pieces. That day and for many weeks after, the death of the princess seemed to be the sole topic of conversation on people's lips.

One week later, on 6 September 1997, Diana's funeral took place in London, attended by 2,000 official guests and around 3 million members of the public who lined the streets for the funeral procession and watched the event on big screens set up outside. The funeral was televised and watched by over 30 million people in the UK and around 2 billion people around the world. During the funeral, many businesses and shops in the UK closed as a sign of respect and the streets became deserted as everyone sat huddled around their TV screens. A deathly hush fell upon the nation as the funeral cortege made its way

from Kensington Palace to Westminster Abbey with the flag-draped coffin of Diana, Princess of Wales, atop a gun carriage pulled by horses. The only sound to be heard was the clatter of the horses' hooves on the tarmac and the occasional sobs of onlookers.

The service at the abbey lasted just over an hour and Prime Minister Tony Blair read an excerpt from the Bible (1 Corinthians 13): 'And now abideth faith, hope and love, these three; but the greatest of these is love.' During the service, Diana, Princess of Wales's good friend Elton John sang a specially adapted version of his song 'Candle in the Wind', which had originally been a tribute to Marilyn Monroe, who also died aged 36. Poor Elton struggled to remain composed as he sang this emotionally charged song in the enormous abbey. Just a few weeks before this he had joined Diana, Princess of Wales, at the funeral of their mutual friend Gianni Versace, who had been shot dead on the steps of his home. A CD single of the song was released a few days later and became the best-selling single ever in the UK. The proceeds from the single were given to the princess' charities and raised an estimated £38 million for good causes.

Of course, the official accounts of Diana, Princess of Wales's death have been much disputed over the years and there are many people who claim that the car crash was no accident. The father of Dodi Fayed, Mohammed al-Fayed, made a public declaration that he believed the death of Diana and his son was a conspiracy which could be attributed to MI6 on the instructions of the royal family.

While no official investigations have ever been able to substantiate any of the conspiracy claims, there are a few pieces of evidence that have not been resolved to this day. In particular,

the wrecked car was found to show signs of an impact with another vehicle, and forensic examination revealed that it had indeed been in contact with a white Fiat Uno in the tunnel. While the suspected owner of the offending Fiat Uno was apparently apprehended by police, he was released with no charges and continues to deny any involvement in the crash and refuses to make any comment to the press.

Also, several eyewitnesses reported seeing bright flashes immediately before the crash which led to speculation that a military strobe may have been used to blind the driver and cause the accident. Some time later, it was discovered that Diana, Princess of Wales, had written letters before the accident in which she said that she believed that there was a possible plot to kill her by tampering with the brakes of her car. While there is plenty of evidence to suggest that there may be more to this case than meets the eye, the official verdict remains as accidental death resulting from the intoxication of the driver.

In 1999, the British public were again shocked by the premature death of a much-loved female celebrity when TV presenter Jill Dando was murdered outside her own home in Fulham, London. The startling incident occurred on 26 April 1999, when 37-year-old Dando arrived at her house and was grabbed from behind by an assailant and forced to the ground. Police evidence showed that Jill was killed by a single gunshot to the head in broad daylight and yet remarkably there was not a single witness to the killing. Even the neighbours nearby didn't notice the gunshot sound since the muzzle of the gun had been pressed tightly to Dando's head to muffle the sound in a style reminiscent of a professional contract killing.

Jill Dando had been voted BBC Personality of the Year in 1997, and at the time of her death was the co-host of the

BBC programme *Crimewatch* with Nick Ross. As a committed Baptist Christian, Jill had also been chosen to present *Songs of Praise* and her career had also included roles as a journalist and newsreader.

The mysterious death of Jill Dando set the tabloids ablaze with speculation as to the motive behind such a horrific attack, and the initial belief was that it may have been a revenge attack for Jill's role in bringing criminals to justice on *Crimewatch*. This theory was soon accompanied by the idea of it being a crazed stalker or even a jealous ex-boyfriend.

One of the more unusual and yet viable theories that surfaced was the idea of it being an assassination sponsored by a Yugoslavian military group. It emerged that the National Criminal Intelligence Service had issued a report that the Serbian warlord leader Arkan had personally ordered Dando's assassination in response to the bombing of the Radio Television of Serbia Headquarters by NATO three days earlier. The Yugoslav government at that time had a history of assassinating its opponents, and just a few days earlier an opposition journalist was assassinated outside his home in an identical manner.

Despite the Yugoslav connection, a local man was arrested and charged with the murder – a man named Barry George who had a history of stalking women and sexual offences. Despite a lack of significant evidence, George was convicted and sentenced to life imprisonment. He appealed against the conviction and on his third appeal was acquitted. To this day the case remains open.

1999 also marked the year when legendary entertainer and comedian Rod Hull died. For many years, children had been entertained by the antics of Rod Hull and Emu, his

A small section of the enormous carpet of flowers laid outside Kensington Palace following the death of Princess Diana in 1997.

ferocious blue puppet sidekick. His performance at the 1972 Royal Variety Performance had launched him to fame and in the 1980s he had his own TV show which, along with Emu, introduced additional characters including Robot Redford (a robot) and Grotbags, the green-faced, child-hating witch played by the late Carol Lee Scott.

Rod Hull and Emu were best known and are still fondly remembered for the bad-tempered attacks of Emu that frequently occurred if anyone got too close to him. During the attacks, Hull would pretend that he was trying to restrain the large bird but would inevitably end up joining in the kerfuffle, sometimes rolling around on the floor with the victim in pretence of trying to save them with one hand, while attacking them with the other!

The wild and unpredictable nature of Emu sometimes caused controversy and, at the Royal Variety Performance that made them famous, Emu grabbed and destroyed the Queen Mother's bouquet of flowers at the line-up after the show. On another occasion he attacked chat-show host Michael Parkinson and knocked him off his chair during the interview.

While it was sometimes entertaining watching a grown man attacking people with a giant children's puppet, there was also something quite sinister about it, as though Emu was actually a manifestation of the darker side of Hull's own personality. During the nineties, Rod Hull and Emu's popularity waned and the pair were relegated to performing pantomime and occasionally appearing in TV adverts. On 17 March 1999, Rod Hull was at home watching the Champion's League football match between Internazionale and Manchester United when he lost the TV signal. This was apparently a fairly common occurrence and so Hull climbed up on to the roof of his bungalow to adjust the television antenna, as he had done many times before. On this occasion, though, while making the adjustment, he slipped and fell off the roof, suffering fatal injuries.

But that's enough about the tragic, mysterious and down-right bizarre deaths of the nineties. The time for mourning is over. Time has separated us from the immediate pangs of grief we felt and given us a new perspective where we can look back with fond memories of those we loved and celebrate their lives and the legacies they have left.

Jill Dando's tragic death resulted in a legacy that included the formation of the University College of London (UCL) Jill Dando Institute of Crime Science, which researches ways to cut crime and increase security. The Princess Diana

Memorial Fund, which was set up shortly after Diana's death, continued operating until 2016, providing over £112 million to help improve the lives of disadvantaged people around the world. And while there's a big John Candy-shaped hole left in Hollywood, we have at least been left with a catalogue of some forty-five movies and many more TV shows to enjoy forever, and his life inspired the creation of the John Candy Visual Arts Studio at Neil McNeil Catholic High School, in Toronto, Canada.

No one can ever replace these beloved people but we can at least console ourselves with the thought that the same decade that saw the departure of these stars also saw a delighted Mrs Bieber take her newborn child Justin into her arms and joyfully sing out the words, 'Baby, baby, baby oh!'

Nine

WORLD EVENTS

For many children of the nineties, world affairs and current events were not something we spent a lot of time considering; we had far more important things on our mind like making sure we fed our Tamagotchi virtual pets or figuring out how to complete *Donkey Kong* on our Game Boys. But despite our total lack of interest in what was going on in the world around us, news leaked into our consciousness from various sources, whether we liked it or not.

Sometimes, we would watch episodes of the anarchic and satirical puppet show *Spitting Image*, not really understanding the political humour, satire and topical references but we would laugh at the funny puppets with their silly voices and songs. Since no one was exempt from ridicule on *Spitting Image*, we were exposed to caricatures of many world leaders, politicians, celebrities and even royalty, and this was how many children learned the names and exaggerated characteristics of the politicians governing our country and the rest of the world.

We would also inadvertently absorb some news stories as we watched an episode of the new current affairs quiz *Have I Got News For You*, hosted by Angus Deayton. Of course, we knew

Angus Deayton better as Patrick Trench, the next-door neighbour and nemesis of Victor Meldrew in *One Foot in the Grave*. By a process of informational osmosis, we would pick up more topical world news while we thought we were just laughing at Paul Merton and Ian Hislop's witty banter.

At other times, we would feign interest in the *Nine O'Clock News* simply as a way to avoid having to go to bed, although, after watching a few minutes of Michael Buerk discussing the political ramifications of policies made by our somewhat dull Prime Minister John Major, the idea of going to bed actually became a lot more attractive.

Our best source of news, though, was from the BBC programme *Newsround*, which presented the news in a way that was accessible to children and adolescents alike. *Newsround* was presented during the nineties by Juliet Morris, Krishnan Guru-Murthy, Paul Welsh, Julie Etchingham, Chris Rogers and Kate Sanderson in turn, and between them they gave us a window on to the events unfolding around the world in a way that was palatable and interesting to us.

One of the first news stories *Newsround* covered in the nineties was that of Nelson Mandela's release from prison on 11 February 1990, after twenty-seven years in captivity. The story was lightweight for its younger audience and painted a picture of a political prisoner unjustly imprisoned for fighting for freedom from apartheid in South Africa. Everybody seemed delighted that Nelson Mandela had been freed and he was treated as a national hero both in South Africa and around the world. It wasn't until quite some time later that we discovered the rather more complicated truth that Nelson Mandela had actually been a Marxist revolutionary and member of the South African Communist Party (SACP) who co-founded

the paramilitary MK organisation which espoused violence as a means to overthrow the government. The MK organisation of which he was a primary member was ultimately responsible for the torture and murder of over 100 civilians, most of them black, and the murder of around thirty security forces personnel.

It was also through the coverage on *Newsround* that many of us first heard about the three-year conflict in Bosnia and Herzegovina, which began in April 1992 and resulted in the deaths of over 100,000 people. The Bosnian War, as it became known, had erupted as part of the breakup of Yugoslavia following the collapse of the Soviet Union, and it was characterised by the indiscriminate shelling of cities and towns and the shocking ethnic cleansing or genocide of its people. Without the coverage on *Newsround*, we would probably have been blissfully unaware of the atrocities taking place in neighbouring Europe.

And again *Newsround* was responsible for educating us as to the events of the Gulf War, which officially began on 2 August 1990 when Iraq invaded and annexed neighbouring Kuwait. International condemnation immediately followed this aggressive move led by Iraq's President, Saddam Hussein.

A combined military task force from thirty-five different nations assembled to form a coalition under the leadership of the United States of America, who provided the bulk of the military resource. Saudi Arabia was the second-largest contributor to the military coalition, followed closely by the United Kingdom who deployed over 50,000 troops to the battlefield along with equipment including tanks, armoured vehicles, fighter jets, submarines, artillery, navy ships and more.

After a period of negotiation, mobilisation and preparation, the coalition forces began their conflict against Iraq on

17 January 1991, striking the Iraqi troops in Kuwait with an aerial and naval bombardment code-named Operation Desert Storm. The bombardment continued for five weeks and was swiftly followed with a ground assault on 24 February, which led to the liberation of Kuwait and a ceasefire after just 100 hours of fighting.

As the Iraqi forces retreated from Kuwait, they followed a scorched-earth policy that led to them setting fire to over 700 oil wells to ensure the 'enemy' couldn't get their hands on them. The oil wells burned, out of control, for many months due to the extraordinary difficulty of quenching the raging fires in the war-torn country.

This was the most televised war ever and, for the first time, the public was able to see live video from inside the war zone and view dramatic images of missiles hitting their targets with pinpoint accuracy. *Newsround* provided sensitive coverage of the war suitable for children to see and understand, but the most detailed reports came from the BBC's reporter in Iraq, John Simpson, who gave a running commentary of every-thing he saw. In one famous report, Simpson was telephoning a report back to London when a Tomahawk cruise missile flew past his hotel, following the line of the street, and turned left at the traffic lights.

Coalition forces were keen to use the media to show off their military capabilities and provided the news outlets with astonishing footage of laser-guided bombs and missiles with cameras on them that were so precise they could apparently be flown through open windows.

On the very first day of fighting, 17 January, Flight Lieutenant John Nichol and pilot John Peters were shot down while car-rying out a raid in their RAF Tornado aircraft. Fortunately the

pair managed to eject from the plane shortly after it was struck by a heat-seeking missile and landed safely around 100 miles behind enemy lines. They were captured by Iraqi troops and were beaten and tortured before being paraded on television and made to read prepared statements. It wasn't until we saw the bruised and beaten faces of our RAF heroes on the television that the reality of the horrors of war began to sink in for many people. With all the media coverage and missile camera footage, it had almost seemed like an extravagant video game until this point.

During the Gulf War, the incumbent president of the USA was George H.W. Bush, who served in office between 1989 and 1993, and who was followed by President Bill Clinton for the rest of the nineties, serving between 1993 and 2001. While George Bush's term passed without apparent scandal,

Money, money, money! The new euro currency introduced in 1999.

the same could not be said of Bill Clinton who ultimately faced impeachment for obstruction of justice during a lawsuit against him relating to his extra-marital affair with the now infamous Monica Lewinsky.

Allegations of an affair between 49-year-old Clinton and 22-year-old White House intern Monica Lewinsky first surfaced in January 1998 and were followed by swift denials of any improper conduct from the president. Of course, this was a dynamite news story and a brief dismissal statement from the White House was not nearly enough to satisfy the media who smelled a big story in the making. Bill Clinton's wife, First Lady Hillary Clinton, stood by her husband publicly, claiming that the accusations were part of a 'vast right-wing conspiracy that has been conspiring against my husband since the day he announced for president'. Subsequent revelations suggest that Hillary Clinton was likely well aware of the reality of her husband's affair at this time and was doing her best to suppress the truth.

As pressure mounted on President Clinton for more in-depth answers to the allegations, he responded by giving a formal statement to the world's press on 26 January 1998. With a defiant attitude, Clinton gave the following televised statement:

Now, I have to go back to work on my 'State of the Union' speech. And I worked on it until pretty late last night. But I want to say one thing to the American people. I want you to listen to me. I'm going to say this again: I did not have sexual relations with that woman, Miss Lewinsky. I never told anybody to lie, not a single time; never. These allegations are false. And I need to go back to work for the American people. Thank you.

Needless to say, President Clinton's story changed somewhat after significant evidence, including intimate DNA samples, proved beyond all doubt that he had indeed had an affair with Monica Lewinsky. In December 1998, the House of Representatives voted to issue Articles of Impeachment against Clinton for the crimes of obstruction of justice and perjury, but the twenty-one-day trial in the Senate which followed resulted in the acquittal of all charges and he remained in office, much to the embarrassment of the American people.

Aside from the Clinton–Lewinsky scandal, the United States of America was also in our news frequently for other reasons. In 1992 we saw terrifying footage of riots erupting on the streets of Los Angeles in an angry response to the police beating of arrested criminal Rodney King and the outcome of the trial against the police officers involved, who were acquitted of any charges of the use of excessive force.

Over a six-day period between 29 April and 4 May 1992, Los Angeles suffered widespread rioting, looting, assault, murder and arson. The riots left sixty-three people dead and over 2,000 injured with enormous damage to businesses and homes in the city. After the riots, over 12,000 people were arrested for their involvement in the unrest.

The following year America was back in British news as we watched the tense stand-off of the infamous Waco siege unfolding. A religious group known as the Branch Davidians, an offshoot of the Seventh Day Adventist Movement, barricaded themselves into their compound after an attempted raid by federal and state law enforcement and the military. Allegations of firearms offences had reached the authorities, who attempted to raid the building but were fought off by the heavily armed residents. A fifty-one-day siege ensued, during

which time various tactics were used to try to persuade the group to stand down, including playing extremely loud music day and night so the Davidians could not sleep. Ultimately an assault was launched by the FBI, who used tear gas as they stormed the compound.

Unfortunately, a fire started, whose origin is still debated today, which quickly engulfed the compound and led to the tragic loss of many lives. In total, seventy-six people died during the raid and much debate continues as to whether the FBI raid was unnecessarily heavy-handed and contributed to the considerable loss of life.

Back in the UK, the political leadership of the nineties began with Conservative Party leader Margaret Thatcher, who served as Prime Minister between 4 May 1979 and 28 November 1990. Her tearful and arguably forced resignation in 1990 opened the door for her successor John Major to assume the premiership – a position he retained until 1997 when a general election led to the installation of a Labour government under Tony Blair.

Children of the nineties will no doubt have little recollection of any of the political achievements (or failures) of John Major but are far more likely to remember him for his *Spitting Image* character, which portrayed him as extremely dull, monochromatic and strangely obsessed with peas. If there was anything else a child might remember about him, it may be his unusually broad philtrum (the area above his upper lip).

In contrast, Tony Blair's *Spitting Image* character was initially an inanely grinning public schoolboy wearing shorts and a cap and blazer. When Tony Blair became Labour leader, the puppet was changed to an inanely grinning politician in a suit.

Humorous caricatures aside, the legacies of these two political leaders continue to be felt throughout the world today. Under John Major's government, the Maastricht Treaty relating to the formation of the European Union (EU) was signed and created what was known as the Three Pillars structure which paved the way for the single European currency, the euro. It wasn't until 1999, though, under Tony Blair's government, that the currency was actually adopted. Overnight between 31 December 1998 and 1 January 1999 the national currencies of numerous EU member states disappeared, including the French franc, German mark, Italian lira and Spanish peseta, to be replaced with the new euro currency.

A seismic shift in world politics occurred during the nineties as Europe continued its agenda of unification and single currency. East and West Germany were finally reunited in 1990, following the fall of the Berlin Wall in November 1989; the Soviet Union officially collapsed in 1991. Hong Kong was returned to China in 1997 after 156 years of British Crown rule and, after many years of violence and turmoil, the Good Friday Agreement was signed which brought an end to thirty years of sectarian conflict in Northern Ireland and IRA bombing campaigns in England.

While complex political changes were taking place that would redefine the future of Europe, the English and French nations were simultaneously working on the construction of a tunnel under the English Channel that would improve transport and trade between the UK and the rest of Europe.

The concept of constructing a tunnel between England and France had been considered as long ago as 1802, and in 1880 an attempt was actually made. Construction began on the English side at Dover and may very well have succeeded had

it not been for political instability at the time which led many to consider the very real threat of invading armies using the tunnel to gain convenient access to England.

The new Channel Tunnel, or 'Chunnel' as it quickly became known, began construction in 1988, just over 100 years after the first attempt; it took nearly eight years to complete and cost a whopping £9.5 billion – double the original estimated cost. Tunnelling with enormous boring machines took place on both sides of the Channel simultaneously, with the English and French teams making their way towards a central meeting point in the middle of the English Channel. On 1 December 1990 news reports showed us jubilant scenes as English and French workers from both sides of the tunnel met in the middle and shook hands with each other through a small gap in the rock.

An enormous collective sigh of relief was breathed as the tunnels met, since there was always the fear that the two tunnels would narrowly miss their rendezvous point and simply continue past each other! The Channel Tunnel became the longest undersea tunnel in the world, running for 31 miles from Folkestone in Kent to Calais in France. At its deepest point, the tunnel sits 250 feet beneath the sea bed and 380 feet below sea level.

On 6 May 1994, the tunnel was finally opened by the queen and the president of France, François Mitterrand, and before long members of the public had the opportunity to enjoy high-speed rail travel between England and France. Freight trains also operated through the tunnel, transporting around 6.5 million tonnes of freight between the UK and Europe in the first full year of operation.

The Sleeping Beauty Castle at what was originally called Euro Disney Resort.

The very same year that construction of the Channel Tunnel began, another formidable feat of engineering and management commenced in Europe – the building of Euro Disney Resort, as it was originally called. In 1998 around 4,800 acres of land just outside Paris were turned into an enormous building site with construction continuing for four years and costing around $5 billion, despite an initial project cost estimate of just $1 billion.

The theme park opened its doors to the public on 12 April 1992 and welcomed 6.5 million visitors before the end of the year. Subsequent years saw visitor numbers rise steadily until, by the end of the nineties, around 12.5 million people entered the park each year, with almost all of them visiting the disturbingly cute 'It's a Small World' ride at least once.

In 1994 the park changed its name to Euro Disney Resort Paris before simplifying to just Disneyland Paris in 1995. The enormous theme park quickly became the number one tourist destination in Europe, beating even the Louvre and the Eiffel Tower in terms of visitor numbers and revenue, much to the concern of many French intellectuals who felt that the theme park served only to promote unhealthy American-style consumerism in France.

When the Channel Tunnel opened for business in 1994, many people from the UK used either the drive-on Eurotunnel rail service or the Eurostar passenger service from London to visit the new theme park, while others used the service to fill up their cars with cheap alcohol and cigarettes from the continent.

Also in 1994, under John Major's government, the licence was granted for a new state-franchised lottery called the National Lottery. In the weeks running up to the first draw

on 19 November 1994, lottery fever gripped the nation partly thanks to strong marketing campaigns with the slogan 'It Could Be You'. Over 48 million tickets were sold for the first draw and even Prime Minister John Major took time away from his plate of peas to have his photograph taken at a newsagent buying his lottery ticket.

The National Lottery was the number one topic of conversation in the final days leading up to the draw. Everyone had a different strategy for picking their 'winning' numbers. Some used numbers that had special meaning for them, such as the ages of their children or birth dates, and others claimed to have calculated scientific methods that would provide them with greater odds of winning. No matter how unlikely the actual chance of hitting the jackpot (nearly 14 million to one), everyone secretly felt that they were going to be the first winners.

Noel Edmonds presented the televised draw and read out the numbers one by one as the nation sat glued to their TV screens. The winning numbers were 30, 3, 5, 44, 14 and 22, with 10 as the bonus ball; seven people shared a jackpot total of around £5.9 million and a further 1.1 million people won prizes of a minimum of £10 each. While the initial excitement wore off pretty quickly, the National Lottery was here to stay and in 1995 it saw its largest ever single jackpot win with a whopping £22,590,829 collected by a double-glazing salesman from Sussex.

The sporting decade kicked off (excuse the pun) with the Italia 90 FIFA World Cup, which was held in twelve different stadiums across Italy between 8 June and 8 July 1990. England started off well with a victory against Belgium, which pushed them through to the quarter-finals. They beat their opponents,

Cameroon, and entered the semi-finals for the first time since the days of Bobby Charlton, some twenty-four years earlier.

On 3 July, England faced their historical footballing nemesis in the shape of West Germany and battled it out on the pitch with great valour. No goals were scored until the sixtieth minute, when Andreas Brehme scored a goal for Germany which was followed shortly afterwards by an equaliser from England's Gary Lineker.

During the match, Paul Gascoine (or Gazza as he is better known to many) received a yellow card from the referee as the consequence of a dubious tackle, which Gazza maintains was a deliberate attempt to have him booked by the German player. He famously wept on the pitch after receiving the booking since this meant that he would not be able to play in the World Cup Final if England made it through to the next round. The outcome of his open weeping in front of the world's press was that he was honoured with a *Spitting Image* puppet that squirted water out of his eyes like windscreen washers on a car!

The game ended 1–1, despite extra time giving an opportunity for a decisive victory, and so the game concluded with a nail-biting penalty shoot-out. Goals were scored by Gary Lineker, Peter Beardsley and David Platt, and each was matched with a goal from the German team. Stuart Pearce came next with a respectable shot but this was blocked by the German goalkeeper. Following another goal from the Germans, it all came down to Chris Waddle. Poor Chris Waddle. The pressure on the unfortunate man must have been unbearable knowing that this was a make-or-break moment and that his penalty shot was the only thing that stood between England's triumphant victory or humiliating defeat at the hands of the Germans. This moment would either make him a hero or a

scapegoat for the loss of the World Cup. In the end, the pressure was simply too much and he took a terrible penalty shot that missed the goal entirely and led to the end of England's challenge for the World Cup.

While the pain ran deep for England, fans could at least hold their heads high knowing that their team had played with great integrity and honour, and the team was the 1990 recipient of the FIFA Fair Play Trophy, an honour that was bestowed upon it again in the 1998 World Cup.

Our national characteristics of integrity and honour were evident again in the 1992 Olympics, held in Barcelona, Spain, when, during a 400-metre semi-final heat, British athlete Derek Redmond tore his hamstring while in fourth position and immediately came to a standstill. Rather than quitting the race, Redmond continued by hopping along on one leg, grimacing in agony as he went. Seconds later, his father dashed down on to the track to support his son, holding on to him all the way to the finishing line, despite numerous attempts by marshals to remove him from the track. The pair received a standing ovation as they crossed the finish line and made us proud of our nation yet again.

Aside from this incident, the 1992 Olympics produced a haul of twenty medals for Great Britain which, although a respectable result, was actually the lowest number of medals since the 1976 games. Sadly, our sporting prowess did not improve at all in the 1996 Olympics, held in Atlanta, USA, which resulted in Great Britain's worst ever Olympic performance with a dismal fifteen medals and only a single gold among them.

Fortunately we did a little better in motorsport in the nineties, with our moustachioed Brummie hero Nigel Mansell winning the 1992 Formula One Driver's Championship,

followed by Damon Hill winning the Championship title for Britain in 1996. Great Britain also did astonishingly well in the Formula One Constructor's Championship in the nineties, winning the top spot every single year except for 1999.

The nineties saw some truly spectacular motor racing, particularly with the highly entertaining fierce competition between hot-headed rivals Frenchman Alain Prost and Brazilian Ayrton Senna. We also saw the Formula One debuts of British World Champion Damon Hill and German motor-racing legend Michael Schumacher, who quickly made his way to the top of the pack with his first Championship win after his third season in 1994.

However, in 1994 the world of Formula One racing was rocked to its core, first by the tragic death of Austrian driver Roland Ratzenberger, who was killed in an accident during a qualifying lap, and then, the following day, by the shocking death of Ayrton Senna, who was considered by many to be the greatest racing driver of all time.

During the San Marino Grand Prix, Ayrton Senna, the three-time World Champion, led the race until lap seven, when his car left the track and hit a concrete retaining wall at 145mph, leaving him with fatal head injuries. When he was extracted from his car, a furled Austrian flag was found in the cockpit, which Senna had evidently planned to raise on completion of the race in honour of the recently departed Ratzenberger.

At the next Formula One race, held in Monaco, the first two places on the starting grid were left empty in honour of Senna and Ratzenberger, and had the Brazilian and Austrian flags painted on the tarmac in their respective places. The double deaths put a spotlight on motorsport safety and ultimately led

Bill Clinton, the 42nd President of the United States of America and the first
person to have admitted to smoking marijuana without inhaling any of it.

to a number of improvements that may well have saved the lives of a number of other drivers since.

Also in 1994, the world of sport was rocked by what became known as the 'Tonya Harding Ice Skating Scandal', when the aforenamed American Olympic skater was implicated in the brutal assault of fellow US team competitor Nancy Kerrigan. On 6 January 1994, Nancy Kerrigan left the ice rink after a training session and, as she walked down a corridor at the arena, she was violently struck on her leg, just above the knee, by an assailant with a telescopic police baton. It transpired that the assailant had been hired by Tonya Harding's ex-husband and her bodyguard with the intent to break Kerrigan's leg and prevent her from competing against Harding in the Olympics. Until this point, few of us realised how fiercely competitive the world of ice skating could be.

Fortunately Kerrigan was not seriously injured and recovered fully in time for the 1994 Winter Olympics in Lillehammer, where she performed outstandingly and won the silver medal. With some semblance of poetic justice, Tonya Harding suffered trouble with her Olympic performance after the laces on her skates snapped and she had to be given a re-skate by the judges. Even then she went on to give only a mediocre performance which landed her in a disappointing eighth place.

While all those involved in the attack served prison time for their actions, Tonya Harding was excluded from incarceration since she maintained that she was unaware of the planned attack and only became aware of it after it had taken place. She was, however, charged with conspiring to hinder prosecution of the attackers and received three years' probation, a $160,000 fine and 500 hours of community service.

While the UK didn't do so well in a number of the big sporting competitions of the nineties, we made up for our sporting shortcomings with our world-renowned musical talents, which brought us fantastic results in the annual Eurovision Song Contest. In 1997, the United Kingdom took first place with the Katrina and the Waves song 'Love Shine a Light', and won second place in 1992, 1993 and 1998. Ireland did even better, winning the number one spot in 1992, 1993, 1994 and 1996, and taking second place in 1990 and 1997.

Arguably the most memorable Eurovision of the nineties for those of us in the UK and Ireland was the 1994 competition, which took place in Dublin, Ireland. Having won the previous year and being on their home turf, Ireland were in fine spirits and put in a fantastic performance with a delightful little ditty called 'Rock 'n' Roll Kids' by Paul Harrington and Charlie McGettigan. During the interval while the scores were being prepared, an unknown Irish dance act called Riverdance was given the stage for seven minutes and an unsuspecting international television audience of over 300 million people settled back in their armchairs to watch the traditionally mediocre interval act.

The act began slowly with haunting vocals from the Celtic choral group Anúna as they sang on the banks of the River Liffey in Dublin. The cameras then cut to the Eurovision stage where leading lady Jean Butler began leaping with gazelle-like dexterity across the stage in a contemporary Irish dance. After a brief solo the bouffant-haired, silk-shirted and extremely flamboyant star of the show, Michael Flatley, came flying on to the stage with legs flailing wildly as if independent from the rest of his body.

USAF aircraft of the 4th Fighter Wing (F-16, F-15C and F-15E) fly over Kuwaiti oil fires, set by the retreating Iraqi army during Operation Desert Storm in 1991.

As the dance progressed, the music and dancing built in a driving and thunderous extended crescendo with more and more dancers joining the stage and flailing their legs in perfect synchronisation with each other. In a wild, whirling finale the dancers gave a breathtaking performance quite unlike anything that had ever been seen before which resulted in a lengthy standing ovation and roar of applause from the ecstatic audience. Michael Flatley's face said it all as he stood centre stage drinking in the glorious moment – it was clearly a deserving response to the fantastic performance and yet there was something a little off-putting about the egotistical and conceited expression on Flatley's face as he revelled in the adoration of the crowd.

Despite Riverdance having comfortably eclipsed the entire Eurovision Song Contest, the show went on and, to make a great night even better, Ireland took first place in

the competition by a comfortable margin. Following the unexpected success of what had been intended only as a one-off interval act, the producers of the performance, John McColgan and Moya Doherty, developed the concept into a full-blown stage show led by 'Mr Crazy Legs' himself, Michael Flatley. The show became an instant sensation and sold out theatres around the world, becoming one of the most successful dance shows of all time.

Of course, the most spectacular world event of the nineties was also the final event of the decade and was something truly special, something that only happens once every thousand years – the arrival of the new millennium!

For many years we had been anticipating the big day and philosophers, scientists and artists around the world had tried to visualise what the world would look like in the year 2000. The science fiction comic book *2000AD* imagined the world as a dystopian environment filled with mutant human/alien hybrids; diminutive American pop star Prince wrote a song about the new millennium all the way back in 1982 entitled '1999' in which he envisaged some kind of apocalypse or judgement day taking place.

While both of these relatively modern predictions couldn't be further from the truth, the more sober-minded American civil engineer John Elfreth Watkins made some startlingly accurate predictions all the way back in 1900.

He correctly foresaw the advent of colour digital photography that could be wired almost instantly around the world, as well as the invention of mobile telephones, televisions and even military tanks. His suggestion that we would no longer require the letters C, Q and X in our alphabet by the year 2000, however, was somewhat quixotic.

OK we have to just pause here a moment to fully appreciate the brilliance of what I just did there. I mean, trying to find a word that includes the letters C, Q and X alone is quite a challenge, but to find one that actually makes sense in the context of the sentence is even more difficult. I mean, seriously, try it. Can you even think of one word with those three letters in it? You wouldn't believe how much time I spent racking my brain to get that paragraph just right.

Anyway, getting back to the topic, aside from a substantial helping of media-fuelled hysterical paranoia regarding the much-touted possibility of global meltdown as a result of the Millennium Bug (covered in detail in Chapter 7), the run up to the end of the millennium actually went pretty smoothly and the world braced itself for the party of the decade, century and millennium simultaneously.

The very first people to witness the dawn of the year 2000 were probably the residents of Kiribati, an island in the Pacific Ocean, although the US Navy Submarine *Topeka* strategically positioned itself underwater so that it was straddling both the International Date Line and the equator to ensure that the USA was technically the first nation to enter the new millennium.

Some fourteen hours later, the new year arrived in the UK and Big Ben sounded the chimes that heralded the arrival of the year 2000. The much hyped 'River of Fire' pyrotechnic display was initiated shortly after midnight, although it didn't really live up to expectations. We had been promised a wall of fire some 200 feet high travelling down the River Thames at a speed of over 700mph. Instead, we got a blinding flash of solid white fire about 50 feet high that was immediately overtaken by the enormous simultaneous firework display. Many people

didn't even realise the 'River of Fire' had taken place and were still patiently waiting for it to start when the fireworks had finished.

I don't know what we were expecting exactly with the new millennium celebrations, but there was a slight sense of anti-climax and perhaps even disappointment when nothing out of the ordinary happened. No planes fell out of the sky, no financial meltdown began and the Four Horsemen of the

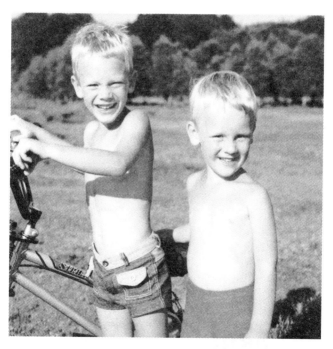

My older brother Martin and me doing what nineties kids did best – playing on our bikes!

Apocalypse were nowhere to be seen. It was really just like any other New Year's Eve except with higher prices for private party tickets and more expensive drinks.

In fact, there was even a sense of loss – a mourning for the end of a decade, a century and a millennium that was our home, the place we came from. We didn't know it at the time but the nineties had been the happiest days of our lives.

The History Press

The destination for history
www.thehistorypress.co.uk